READ THIS IF YOU WANT TO BE GREAT AT DRAWING PEOPLE.

SELWYN LEAMY

Published in 2019 by
Laurence King Publishing Ltd
361–373 City Road
London EC1V 1LR
email: enquiries@laurenceking.com
www.laurenceking.com

This book was designed and produced by
Laurence King Publishing Ltd, London.

A catalogue record for this book
is available from the British Library.
ISBN: 978-1-78627-512-7

Read This if You Want to Be Great at Drawing is
based on an original concept by Henry Carroll

Design: Alexandre Coco
Cover illustration: Akio Morishima
Picture research: Alison Prior
Illustrations: Selwyn Leamy

Printed in China

READ THIS IF YOU WANT TO BE GREAT AT DRAWING PEOPLE.

SELWYN LEAMY

Contents

Why draw people?

There are two really good reasons to draw people. One, because if you can draw people, you can draw anything. Two, because people are so interesting.

The skills and techniques used to draw the face and figure are all totally transferable and can be used when drawing anything else. I touched on some of these techniques in *Read This if You Want to Be Great at Drawing* and we'll revisit them here. It's a fact that drawing the complexities of the human form provides the best foundation to drawing in general, and drawing in general is one of the best foundations for doing anything creative.

But drawing is more than just technique – that can be learnt and practised. Drawing, and especially drawing people, is all about looking and developing your inquisitiveness. Being nosy. People are telling us stories all the time – through their expressions and their posture, through their outfits and through their mannerisms. Drawing people is like a lens that brings them into sharper focus.

Observation, technique, curiosity. That's what it boils down to.

So, what is a drawing of a person? Is a portrait just a drawing of a person's face? Is a figure drawing simply a drawing of an anonymous body? Well these are the traditional conventions, but, like all good artists, we are not going to worry about convention. This book isn't divided into sections labelled 'Portraits', 'Life Drawing', and so on; the techniques used for drawing the face are the same as for the figure. And they are always underpinned by looking.

Artists have been drawing people for centuries, and we are going to study some of their drawings to discover our own way of capturing the people around us. All of these artists had their own styles and their own motivations, but remember, it's important to keep exploring; what you'll see in the pages that follow is just the tip of the iceberg.

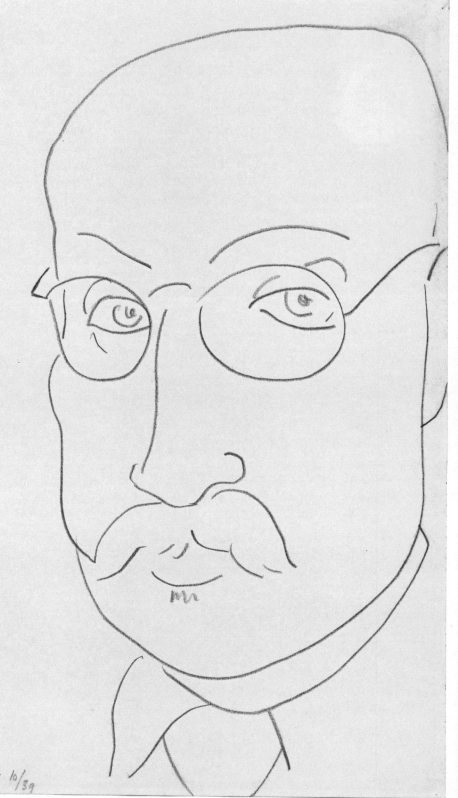

H. Matisse 10/39

Starting out

People are complicated. The best way to approach drawing them is to keep it simple, especially at the start. The drawings in this section have their own unique simplicity: for some of the artists, simplicity was the goal for their end product; for others, simple drawings offered a way of playing around and working things out. But regardless of how they came about, all of these drawings are interesting and worthwhile in their own way.

Matisse was a master of summing up complicated subject matter in a quick sketch. He didn't worry too much about precision or proportions, but concentrated solely on shape. Look at this self-portrait. Matisse ignores all of the complicated bits, refining his face down to just a few clean, confident lines.

Even the most complicated things are simple underneath.

I know that 'keep it simple' is easy to say, and harder to do, and a simple drawing is rarely effortless, but the key is to look before you start drawing. Actively looking trains your eye to see past unnecessary distractions and to focus on the key elements that make up your subject.

The drawings featured in this chapter are all followed by a practical exercise to try, each with a time limit. Try to stick to these time limits because they will help you to work instinctively and avoid overthinking things. This is about developing the relationship between your eye, brain and hand... and getting them all to trust each other. It sounds weird, but give it a go! All you need is an A4 sketchpad and a 2B pencil. Not even an eraser.

Self-Portrait
Henri Matisse
1939

A few good lines

In this portrait, Barry Flanagan's friend, art collector Jack Wendler, looks down, maybe concentrating on some artwork he's thinking of buying. A few swift strokes of the pen capture the moment with no distracting detail – just a thoughtful, clear drawing.

Like Matisse, Flanagan was able to condense his subject into a few simple lines. In this drawing he captures the distinctive profile of his friend. One confident line describes the strong shape of the head, followed by the nose, and after that, just a few marks cleverly suggest the rest – the hair, the ear and the beard. Flanagan wasn't afraid to leave things out.

When you look, try to identify the lines that are essential to forming the likeness of your subject. It may seem counter-intuitive, but the more you look, the more you will want to see past what isn't necessary, focusing instead on those few lines that will really capture the essence of your sitter.

What you leave is more important than what you put in.

EXERCISE:

4 drawings

2 minutes each

1 drawing per page

Draw a self-portrait. No shading, just lines. Find the essential shapes of your face. It doesn't matter where you start. Each drawing will become more simple until you are left with just a few lines.

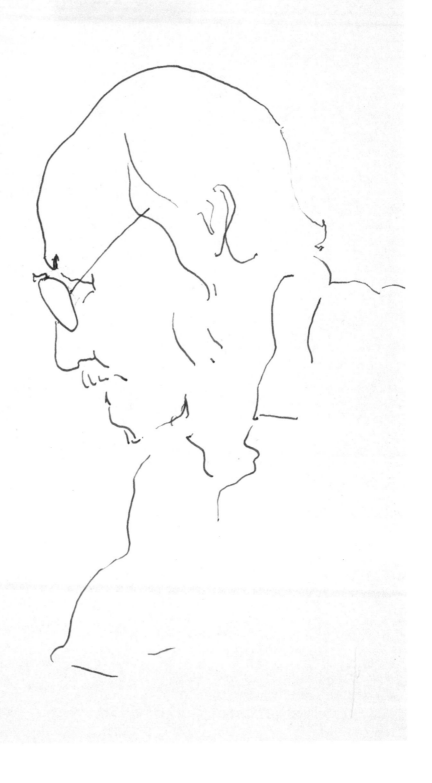

Jack Wendler
Barry Flanagan
1974

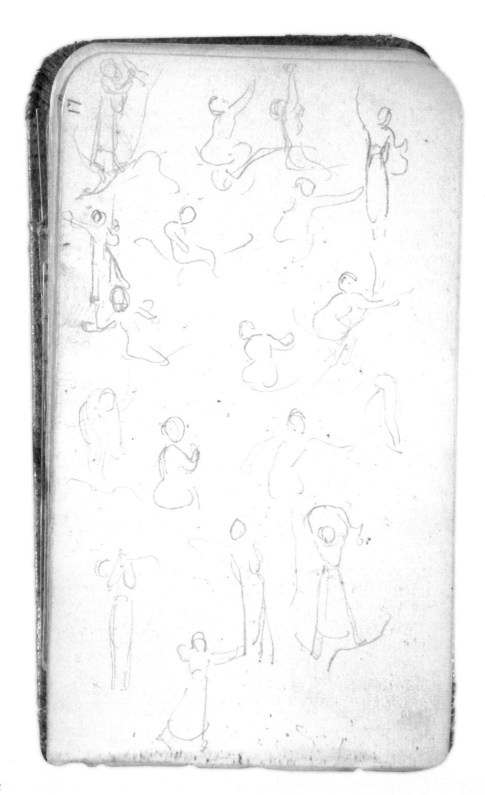

Quick, simple, fun

Each resembling a little pencil haiku, this page of drawings by Victorian artist Frederic Leighton shows that you don't need features or details to make expressive drawings.

Leighton's subjects for this drawing were not posed, or even stationary. But despite taking only a few seconds to complete each one, he captured a sense of their posture or movement, working quickly and simplifying the figures into a handful of lines. Leighton cleverly creates a shorthand for the figure, finding the key components of a pose – the curve of a spine, the arc of a shoulder, the subtle rigidity of an outstretched leg.

Leighton wouldn't have agonized over these drawings; they are quick and simple. Working like this means that you naturally edit out extraneous details, simply because you haven't the time to put them in.

Working quickly concentrates the eye, hand and mind.

Seated, Dancing and Reaching
Female Figures
Frederic Leighton
1870

EXERCISE:

10 seconds per figure

(as many figures as you can fit on a page)

Sit in a café or on a bus and draw the people around you. Like Leighton, hone in on those essential few lines that capture their poses. Be quick and fill the page. If you make a mistake – it doesn't matter, move on and start another one.

Feel your way

Joel Tidey's energetic drawing is about shape and gesture rather than detail. Even though this is a drawing of a girl relaxing, curling back into an invisible chair, Tidey still manages to give it a sense of dynamism, with the figure emerging out of a tangle of lines.

Tidey feels for the form of the figure. The first layer of marks is light and loose, the great weaving swoops describing the shape of the pose. As the form emerges, he increases the pressure of the mark to create a clear, dark outline, but only when he's happy that that particular line is the right one to define the figure.

Drawing like this is quick and intuitive. The first lines you put down are exploratory; your pencil is following the course of your eye as it scans the surface of your subject. Marks then become surer, probing and more defined as you find the 'right' lines to describe your subject.

If the first line you get down isn't right, just go over the top.

EXERCISE:

3 minutes

You don't need to attend a life-drawing class for this exercise – a friend or family member watching telly will work well. When you start, try holding your pencil loosely and further down, away from the tip. This will help create the lighter, freer lines. Get lots of lines down. If they're in the wrong place, simply go over them until you find and can define the shape of the pose.

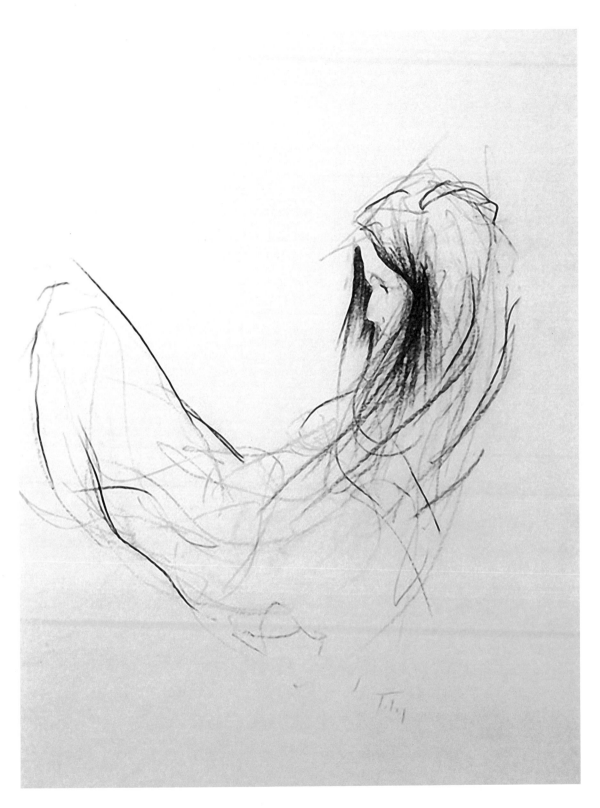

Gesture
Joel Tidey
2014

Look before you draw

Two hundred years ago, drawing the female form was all about sensuality and seduction. Monsieur Jean-Auguste-Dominique Ingres's preparatory drawing for his painting of *La Grand Odalisque* exemplifies that perfectly.

In this elegant drawing, the nude figure of the Odalisque provocatively turns her back to the viewer. The subtle shading gives delicate form to the femininity of her naked figure, but it is the shape of the pose that is so striking. Ingres accentuates his subject's elegance and sensuality by elongating the curve of her back. This subtle stretching of the spine creates an exaggerated 'S' shape that underpins the structure of the whole drawing.

Spend a minute really looking at your subject before you start drawing. You don't have to exaggerate like Ingres, but identifying a figure's underlying shape and structure will give you a strong foundation for the rest of your drawing.

There's a simple structure underpinning every pose.

EXERCISE:

7 minutes

2 minutes only looking

5 minutes drawing

Look particularly at the spine, shoulders and knees. These are the features of a figure that will often allow you to pinpoint the shape of a pose.

Study for La Grand Odalisque
Jean-Auguste-Dominique Ingres
1814

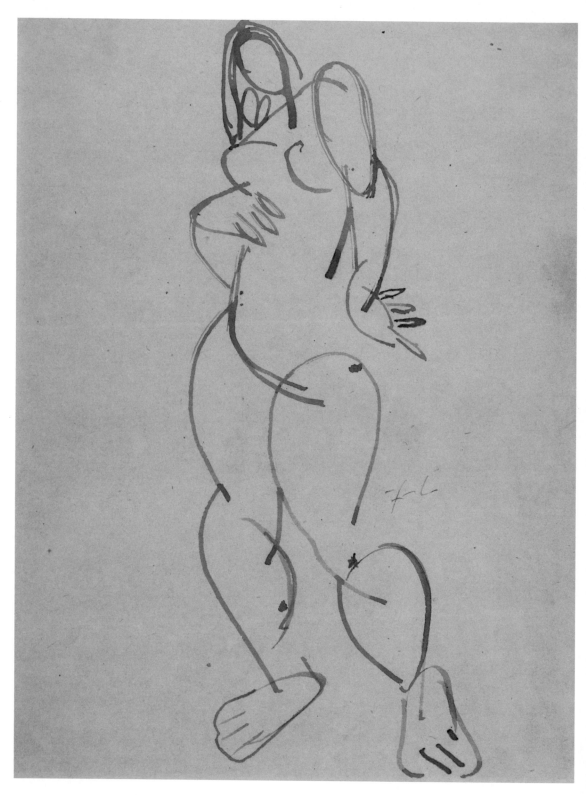

Standing Female Figure
Fernand Léger
1911

Building blocks

The exaggerated curves, and the apparent effortlessness of the shapes, make this drawing seem almost childlike, but behind this simplicity is sophistication.

The curvy female figure looms above us, her hand on her hip, with the subtle lean back of her pose suggested cleverly but simply by the reduced size of the oval-shaped head. Léger has caught the feeling of the pose perfectly, with the weight firmly placed on the right leg, and the steep angle of the shoulders described with a single line. The solidity and physicality of the subject is captured brilliantly in a series of uncomplicated ellipses, drawn with swift pen strokes.

Don't go diving in looking for detail. We've talked about establishing the shape and gesture of a pose, but you also need to think about the weight and physicality of a figure.

Simple shapes help you capture form and structure.

EXERCISE:

Create a drawing with a series of simple shapes like Léger's sketch. If you don't have a model to pose for you, try working from a famous painting instead.

Only have eyes for your subject

This sketch depicts the stoic expression and restless body language of a soldier as he waits for whatever order could put back him on the front line. As an official war artist in the Gulf, Juhasz would have only seconds in which to capture action, horror or, like here, quiet moments of downtime.

Juhasz responds directly to what's in front of him – his drawing is made up of swift, expressive strokes and searching lines, created with his eyes almost constantly locked on his subject, barely looking at the drawing itself. For Juhasz, the only thing that matters is the person he is drawing.

It's easy to keep staring at a drawing and wonder why it's going wrong. Nine times out of ten it's because you are not looking at your subject enough. Everything you need for a successful drawing is there in front of you. Think of it this way – you should spend at least 80 per cent of your time looking at your subject.

Spend at least 80 per cent of your time looking at you subject.

EXERCISE:

2 minutes per drawing

3 drawing per page

You can do this anywhere there are people. Keep your eyes on your subject and only your subject; don't look at your drawing. Don't have any preconceptions about what you want your drawing to look like, just keep looking at every element of the person as your pencil moves across the page. Be prepared to do a lot of drawing.

7-31-2011
SPC E-4 JOHN SPARKS
CHARLIE 1-52
ALTIC DUSTOFF

Gulf War
Victor Juhasz
2011

Who are you looking at?

When it comes to who, you don't have to run out and hire a model – there are plenty of other options for practising and honing your skills:

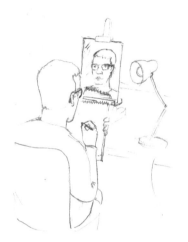

YOURSELF

The self-portrait is a classic subject. You are always around, so you are the perfect model. You don't need to be restricted to just your face, either – don't be afraid to explore other parts of your body.

STATUES IN GALLERIES AND MUSEUMS

Working from statues and busts is great practice when it comes to drawing people. They don't move, and they won't mind if your drawing ends up looking nothing like them. Many museums encourage drawing, and even provide stools to make the experience a little more comfortable.

PAINTINGS IN GALLERIES AND MUSEUMS

This may seem a bit strange, but basing sketches on the work of the great masters is a wonderful way to develop your understanding of poses. Just remain aware that you are working from a surface that is already two-dimensional.

FRIENDS AND FAMILY

Your friends and family are a fantastic and forgiving resource when it comes to practising your drawing techniques, but they are also a great subject to explore. They are the people you know and love and have spent time with, so what better people to commit to paper?

STRANGERS

We're surrounded by them. They are not going to stop doing what the strangers around you are doing for you, but they are an endlessly fascinating resource when it comes to practising quick sketches.

MODELS

An organized life class is always a great place to develop your skills and push yourself. You don't have to be Leonardo da Vinci to attend one, either – there are classes available for all abilities.

Reference material

1

OBSERVATIONAL DRAWING

Drawing from real life is the traditional approach to drawing people, and the way that many artists and art teachers will say is the only way to draw the human form. It's not the only way, but it is a great way to draw, and all the techniques in this book are about drawing from direct observation.

When drawing from life you are taking something three-dimensional and transferring that to a two-dimensional surface – paper. This is the challenge. The advantage in working from life is that you can see everything; all the visual information you need to create a drawing is there in front of you, unfiltered. This means that you are in total control of what you put in and leave out of your drawing. One consideration when drawing from direct observation is that people have a tendency to move. When making candid sketches of strangers, you have to expect this, but even the most experienced life model will move ever so slightly as they hold a pose. This is where you have to be prepared to adapt or just remember. Adaption and memory are important skills for any artist working from life.

BARRELLING OR LENS DISTORTION
The subject is too close to the lens
so features are distorted.

2
PHOTOGRAPHIC REFERENCES

Working from a photograph is easier in many ways. For a start, subjects don't move. They are also already two-dimensional so transferring them to paper is more straightforward. However, a drawing done from a photograph will often look like it was done from a photograph. This is because the lens of a camera will add slight distortions to an image. Although these distortions are subtle, they can become very obvious when drawn. One such distortion is known as

barrelling, which will make certain features look disproportionately large.

A photograph is an edited version of real life. Because a camera is not as sophisticated as the human eye, it cannot incorporate all of the available visual information. Instead, the camera can only select either the lightest area or the darkest area to expose. This means that shadow will look like a large area of black in a photograph whereas in real life there is a greater range of tones.

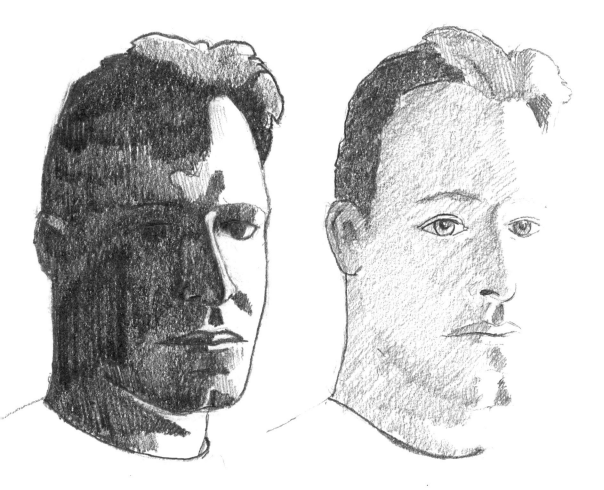

UNDER-EXPOSED PHOTOGRAPH
Large areas are just black.
The detail is obscured by shadow.

OVER-EXPOSED PHOTOGRAPH
Large areas are bleached out and just
white. The detail is obscured by the light.

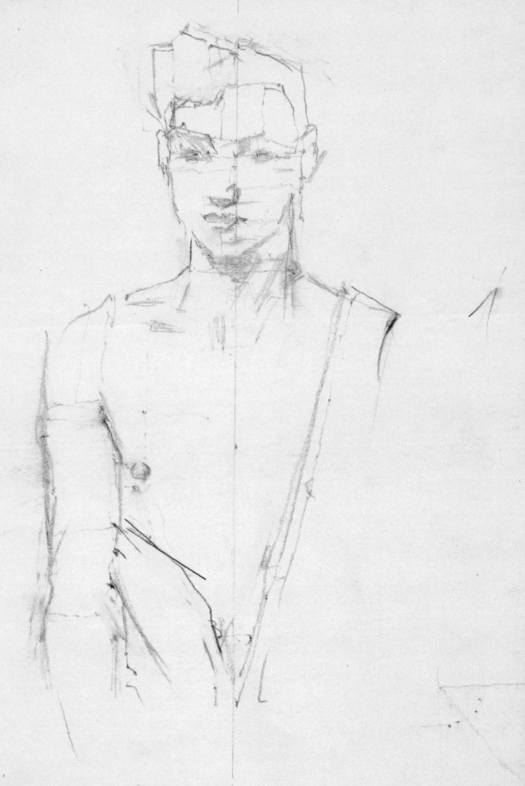

Charlie.
90 60 30 15
JWR. March 7th
1931

Accuracy

The human form is both familiar and mysterious. That's why it's such an amazing subject matter, but also such a daunting one. The previous chapter was about working quickly and instinctively. This chapter is about slowing things down and being more considered. We will look at some simple techniques that will help you break down the process of drawing a figure or a face into more manageable stages.

You need to break it down to build it up.

Transferring a subject from the real world to a sheet of paper doesn't happen in one easy swoop. Making a drawing that captures the complex structure of the human form requires patience – there will be times when your drawing won't look anything like the person in front of you.

This sketch of Charlie Parker shows the process that Denman Waldo Ross used to develop an accurate drawing. All sorts of marks and lines were employed to gauge the position of different elements. Note how many of the marks at this early stage were tentative and light, making them easier to change and move as the drawing developed.

This is often how a drawing comes together – not as a complete form, but evolving slowly. The key is adaptation. Your first line isn't always the right line, so be ready to change it. Spending time working on minute detail can be heartbreaking if you later realize that the proportions are all wrong. Get the whole subject down in a rough but accurate form, before moving on to detail.

Charlie Parker
Denman Waldo Ross
1931

Measure and mark

At times, Euan Uglow seems to have been more like an engineer than an artist. His work is beautifully precise, and his drawings show all the workings and annotations that helped him give everything a laser-like accuracy.

This process was slow and meticulous. Uglow would use his pencil to measure and re-measure, comparing one part of the figure to another to make sure all the proportions were correct. Small marks went down first to map where the lines would ultimately go. Uglow would mark the position of key elements of the figure, constantly making tiny alterations as he checked and re-checked the lines. Only once his proportions were accurate would he commit to a definite outline.

Get the fundamental elements of your subject in proportion.

Study for The Quarry,
Pignano
Euan Uglow
1979

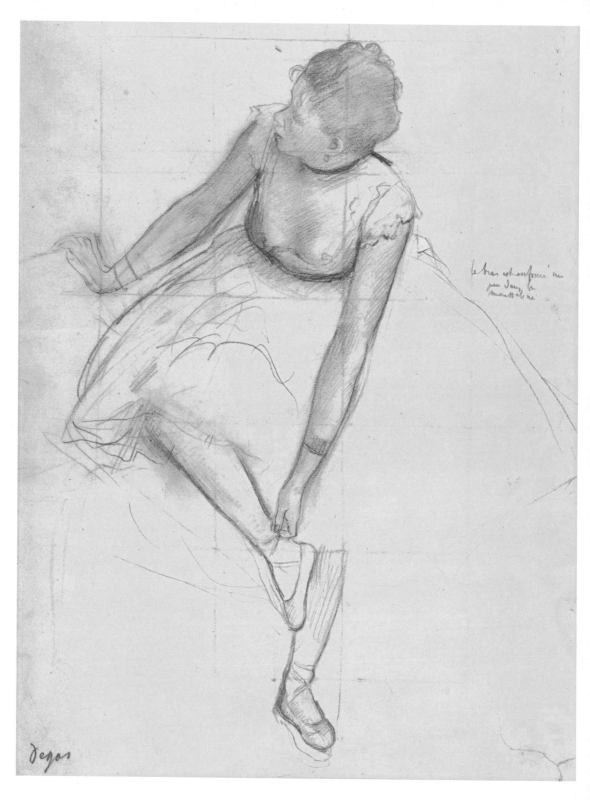

Dancer Adjusting Her Slipper
Edgar Degas
1874

Build relationships

This is one of a series of drawings that Degas made as preparation for a larger finished piece (*Dancers Resting*, 1874). It depicts a fleeting moment – a dancer adjusting the ribbon of her shoe – but this drawing isn't just a quick sketch.

Degas has caught the easy grace of the ballerina. The tutu is light and sketchy, but the dancer's elegant pose, the tilt of her head and the angle of her body are clearly defined with a weight and solidity.

In this example Degas used a grid to transfer his drawing to canvas, but that is not the aspect I want to highlight here. Instead, I chose it to demonstrate a way of figuring out the angles of a figure, and the importance of gauging where one feature of a figure sits in relation to another. Key 'landmarks' like knees, wrists and shoulders can really help guide your drawing.

If you work out where these landmarks are in relation to one another, you are well on your way to a successful drawing. You do not need to draw a grid across your page for this – just use your pencil to run imaginary lines vertically and horizontally across the body.

Accuracy is about seeing the relationship between key features.

On the horizontal plane the dancer's wrist is on the same level as the bottom of her chest, and cuts midway across the top of her opposite arm.

On the vertical, the right w shoulder is clearly in line with the dancer's right ankle.

Guidelines

As with the angles of the body, capturing the angle of the head can be tricky. If it changes, the proportions and positioning of the features will suddenly become less clear.

In this drawing by Renaissance master Leonardo da Vinci, the gentle tilt of Mary's head conveys her grace and calm beautifully. The four little sketches to the left show where he worked out of the angle of the Madonna's head and the direction of her gaze. Preparation was key in Leonardo's process, and he would often use faint guidelines in the early stages to make sure that the angle and position of the various features was correct.

Vertical and horizontal guidelines were useful in the previous chapter. Here you can see that drawing light lines in the early stages of a drawing can help you work out the levels of the eyes, for example, or check that the angle of the mouth is correct. The detail and exact shape of the features can be worked on when you know everything is in the right place.

Guidelines help keep your subject's features in the right place.

The eyes and the mouth should align on the horizontal plane, according to the tilt of the head.

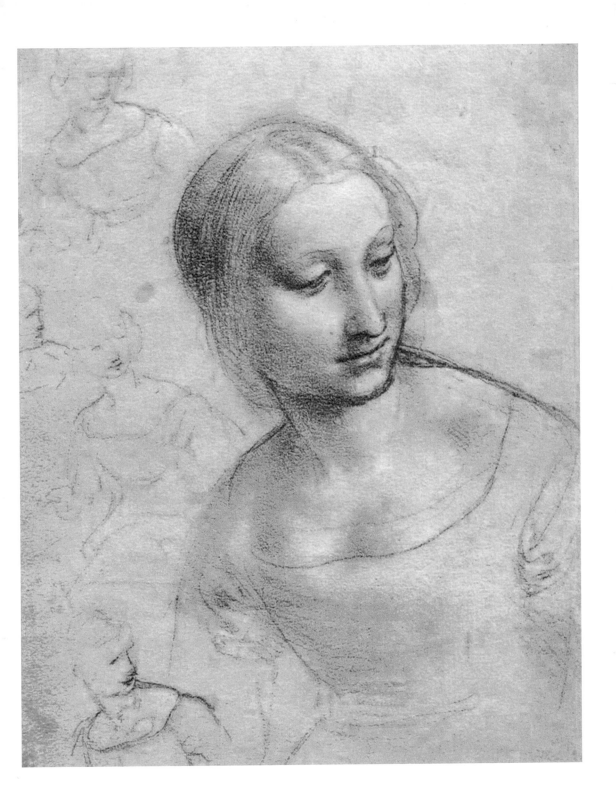

*Study for the Madonna
of the Yarnwinder*
Leonardo da Vinci
1501

Underneath

THE SKELETON

The human body is an amazing thing. It moves, bends, stretches, jumps and does loads of other important and useful things that we don't even think about most of the time. It is an incredibly sophisticated machine and, as with all machines, many of the really clever bits aren't even visible.

Underneath the surface we have all sorts of things going on. Just under our skin we have muscles, nerves, sinews, ligaments and organs, and beneath all that, a skeleton, the structure that keeps everything supported and protected.

This might sound a bit like a biology lesson, but understanding the body's structure and how it 'fits together', and therefore why we move and look the way we do, is key to drawing it accurately.

There are certain areas to pay special attention to.

The neck connects the head to the body between the jaw and the curved back of the cranium.

The shoulders determine much of the posture of a person – you have two clavicles (collarbones) that lie horizontally, forming a strong line.

The spine determines the shape of a pose or posture; it is flexible, consisting of 33 vertebrae.

The pelvis (hip bone) is a large bone that connects the top half of the body to the bottom. The hips also determine much of the shape of a pose. Note that the top of the hips are almost as high as the naval. The shape of the pelvis is slightly different in men and women.

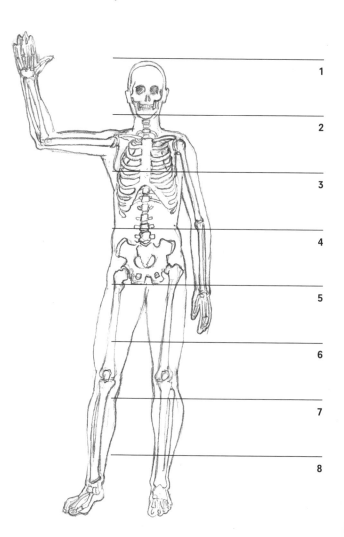

1

2

3

4

5

6

7

8

THE SKULL

The skull, like the skeleton, determines and shapes most of what we see on the surface. Place your hands on your face right now: press gently and you will feel the hardness underneath – the cheekbones, the eye sockets (always surprisingly big), your jawline, which runs into the softness of your neck. All of these things literally shape the way you look.

As with the skeleton, there are some general rules when it comes to the skull.

The middle of the eye socket is in the middle of the head. This is easy to forget when we look at a person because we usually focus just on the face beneath the hairline, and don't look at the head as a whole.

The eyes are set much further back than you think. If you look at the skull in profile, the back of the eye socket is almost in line with the middle of the jaw.

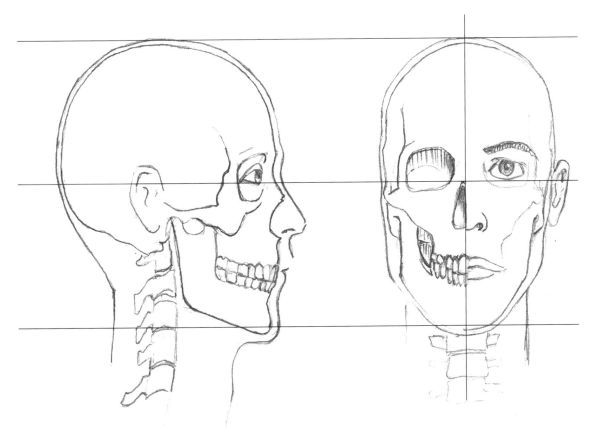

Shoulders and hips

Leda twists her body slightly, dipping her shoulders as she caresses the neck of the swan, and her hips angle in the opposite direction as she places all her weight on one leg. This pose is known as 'contrapposto' and it's all about hips and shoulders.

There's no doubt that this is a sensual drawing. One of the reasons that this pose became so popular in the Renaissance is because the S-shaped curve of the pose gives the figure a sexy shape and rhythm. Raphael loved this beautiful contrapposto Leda so much he copied this drawing from one by Leonardo.

Whatever the pose or posture, the shoulders and hips are the two main axes of the body. Imagine two lines running across the shoulders and hips – use your pencil to help you with this. If you draw these in lightly as guidelines early on, they will help you capture the basic structure of the pose.

Find the angle of the shoulders and hips early on.

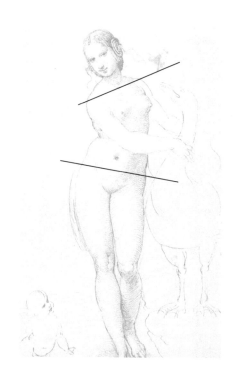

Here the shoulder and the hip are the extreme points. Drawing lines through each makes the angles much easier to see.

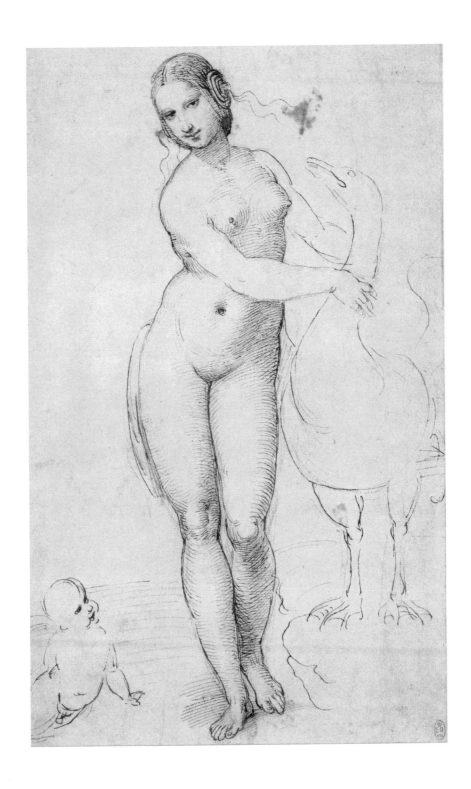

*Study of Leonardo's
Leda and the Swan*
Raphael
1507

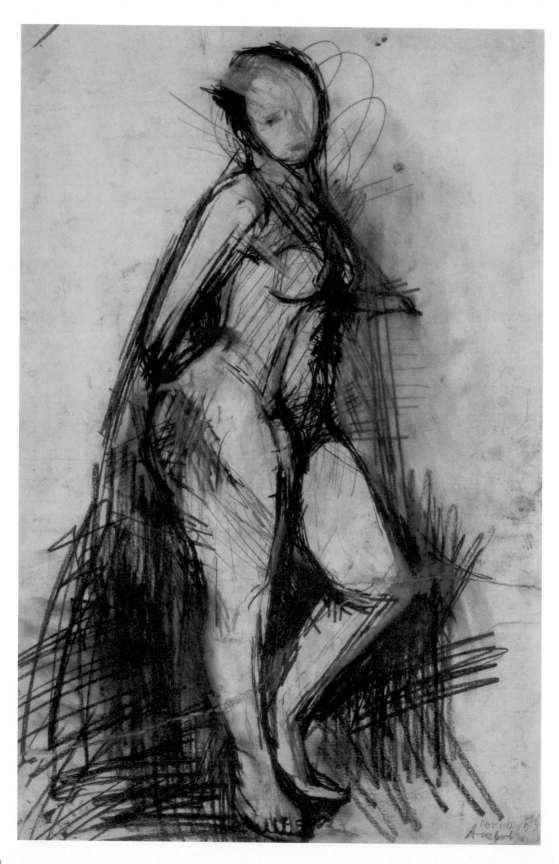

Negative space equals positive results

Bold curves and shapes dominate this drawing – Auerbach has almost carved the figure out of the heavy, dark marks that he's put around it.

The pose of this model is similar to Raphael's Leda, but stylistically this drawing is completely different. It is all about physicality. Auerbach gives the drawing weight with vigorous marks at the bottom, tapering to a smudged-out face at the top, with only the slightest traces of the model's features.

Auerbach's strong marks draw attention to the space around the figure, but this in turn emphasizes the shape of the body itself – the arcs of the thighs and calves, and the angular upper body. The shape of the space immediately around the figure – known as 'negative space' – defines the shape of the figure itself.

Find the negative space by looking around your subject, as well as at the spaces between various parts of the figure. Use your pencil to help you. Close one eye, hold your pencil out straight and join the extreme points of the figure. This will 'enclose' the space, making the negative space easier to see.

Look at the space around the figure to see the shape of the figure.

Standing Female Nude
Frank Auerbach
1955

Build it using boxes

An angular figure lies on an equally angular bed of cushions. Angular, boxy, beautiful.

This drawing is all about structure, emphasized by the fact that the artist has treated the figure and its environment in the same way – both are simplified into geometric shapes, and both are defined by strong straight lines. These cuboid shapes give the figure a simple solidity; there is no unnecessary detail – the whole image deals purely with structure.

Creating a convincing feeling of depth and volume when drawing a figure can be a challenge, since people have curves and bumps all over the place. Catherine Kehoe irons out this problem by presenting the scene as a series of straight, angular facets, almost like it is made from cardboard boxes.

Kehoe's approach results in wonderful sharp-edged drawings, but this technique is also a useful way to create the form of your figure early on in your drawing. Seeing the large components of the figure, like the head and torso, as boxy cubes helps to create depth, establish proportions and secures the underlying accuracy of the structure before bringing in the details.

Breaking the figure down into simple geometric shapes helps create a feeling of form.

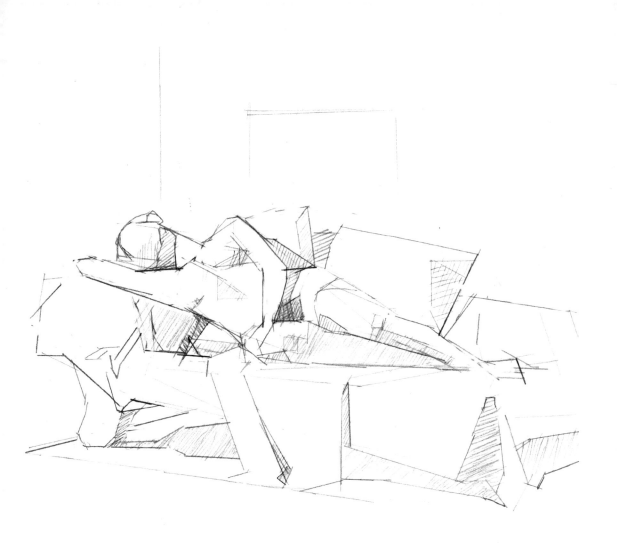

Model at Black Pond
Catherine Kehoe
2016

Scale and proportion

Building up an accurate representation of a person is a bit like a puzzle – it's about working out where things go in relation to others and getting them in the right proportion. A key technique for keeping things accurate is to measure your figure, and this is where your pencil will prove itself to be more than just a tool for drawing.

This attention to structure happens at the early stages of your drawing. Work lightly because things are going to change; at this point you will only be making small marks to note the position of key features rather than actually drawing them.

Comparing one measurement with another will keep your drawing in proportion. But it will also let you get the scale of your drawing right. It's easy to start drawing, then halfway through realize that you're not going to be able to fit the whole figure in. To avoid this, mark out where you want your figure to be positioned.

When working from a model it is good to work on an easel because that puts you in the best position to see both your drawing and the model. You don't have to have an actual easel, but it is important to position yourself so you can comfortably see the model and your drawing. Your position in relation to the model will affect the look of your drawing. If you are looking down or up at your model the proportions will be skewed – this is called 'foreshortening'. So keep measuring. In this example we are looking down slightly on the model, which means that her legs appear shorter.

1

Decide where you want your subject to be on your page and mark that out. If you want it to fill most of the page, draw a short line at the top of the page, which is where the top of the head will be, and another at the bottom of the page for the feet.

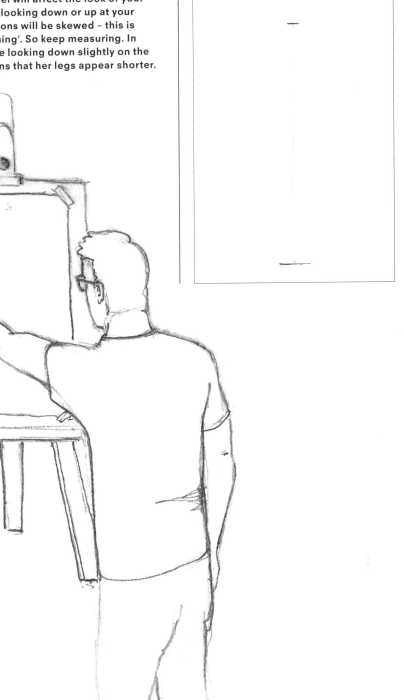

2

Next, use your pencil to measure the head of your model. To do this, hold your arm out straight and align the top of the pencil with the top of the model's head, then slide your thumb down until it is level with the chin.

Now you have a fixed measurement. (It doesn't always have to be the head – that's just usually the easiest fixed measurement to work with.) Count down the figure to see how many times the head fits into the body. In this case it's 5.

Divide the space between your two marks into 5 and you will have a layout that will ensure your drawing fits on your page. This will also provide you with the means to keep everything in proportion.

3

Now lightly mark in the position of the head and other parts of the body. Keep things rough at this stage – you are just planning out your subject.

4

You can now use the fixed measurement of the head and compare it to the measurements of other parts of your subject.

5

Flip your pencil so that it's horizontal, and remember always to keep your arm fixed straight, otherwise the measurements will not be consistent. Now count how many 'heads' fit from shoulder to shoulder.

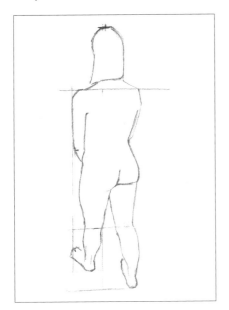

6

Look for the shapes that make up the form of the body. You can lightly draw these in as you go . These help keep the structure of the pose.

7

Look for the negative space. Hold your pencil out in front of you and close one eye (this helps to 'flatten' the scene). Position your pencil against two extreme points of your model (here the shoulder and the buttock). This creates a flat shape that helps you see the form of the model more clearly.

8

In the last stage simply neaten up your drawing. Rub out any marks or guidlines that you might have put in as you were working.

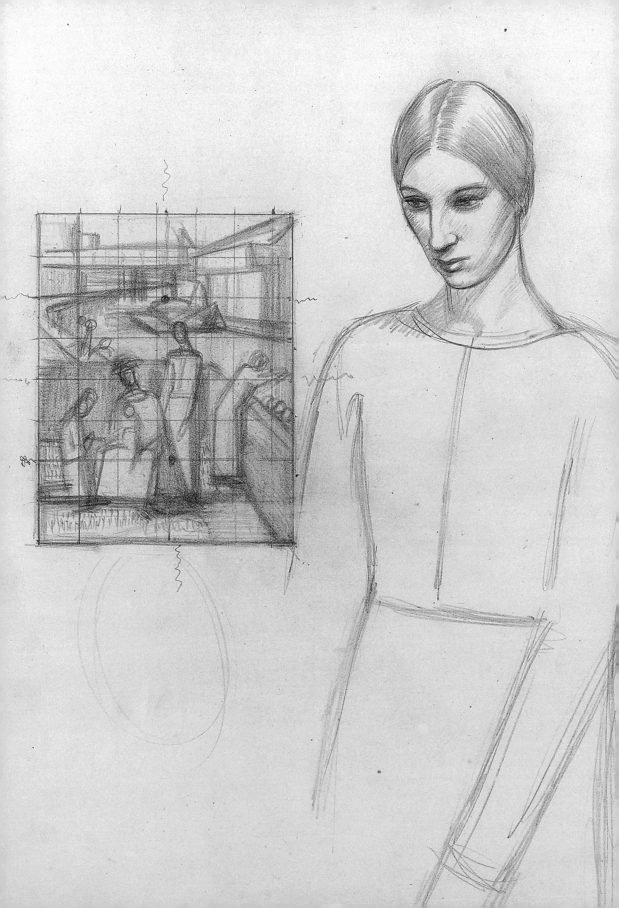

Composition

Composition is simply how you arrange things on the page; it is one of those things that is so important that most of the time you don't even notice it.

You can plan your composition, or you can be instinctive. In quicker sketches your drawing will be much looser, and the position of things will evolve as you go along. In a longer drawing, you have the time to be more considered and spend time planning where the elements of your drawing will go.

In this simple self-portrait Knights carefully arranges the elements of the drawing to subtly guide our eye. She is pushed over to the far right of the composition, almost cramped. Her arm in the foreground leads our eye up to her delicately rendered face, but then her unseeing gaze shifts our own gaze to her drawing on the left. A composition in a composition. There is a delicious tension between the two, a competition between her and her work, like a subtle joke.

Composition is key, because it guides the viewer's eye around your drawing.

Whether a quick sketch or longer drawing, the composition will really affect how the viewer understands your drawing. It is good to figure out what your focus is, so that you can choose where to place it on the page. In this chapter I'll talk about rules, but there are no rules, really – just helpful guides and techniques that can make your work more arresting. Knowing a bit about compositional techniques is always useful, even if you end up ignoring them all!

Self-Portrait with
Compositional Design
Winifred Knights
1919

Go off-centre

In this drawing, Pasternak covers the whole page with marks and swirling lines, but the absolute magnetic focus of the composition is the gaunt, rather stern face of the poet Rilke.

Pasternak draws our eye directly to the poet using one of the most fundamental 'rules' in art – the rule of thirds. This is based on the theory that the eye finds it more comfortable to rest along an axis on the third, vertical or horizontal. We can see here that Pasternak purposely positions the poet's eye precisely on the intersection of the vertical and horizontal third axes. He carries the viewer's eye through the picture, following at first the hubbub behind, then travelling around all the swirling lines up to meet the subject's eye.

In this drawing the focus is on the exact third – it doesn't have to be, but it is important to recognize that the most significant part of your composition isn't always in the middle. Simply moving the focus of your drawing away from the centre can create a much more pleasing and arresting composition.

The rule of thirds maintains balance even when the subject is off-centre.

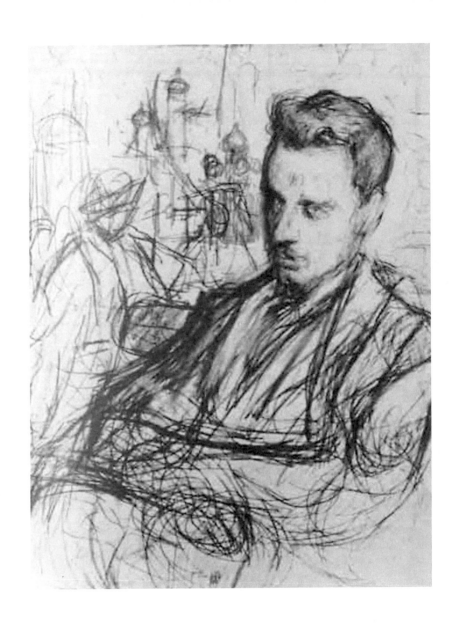

Rilke in Front of the Kremlin
Leonid Pasternak
1928

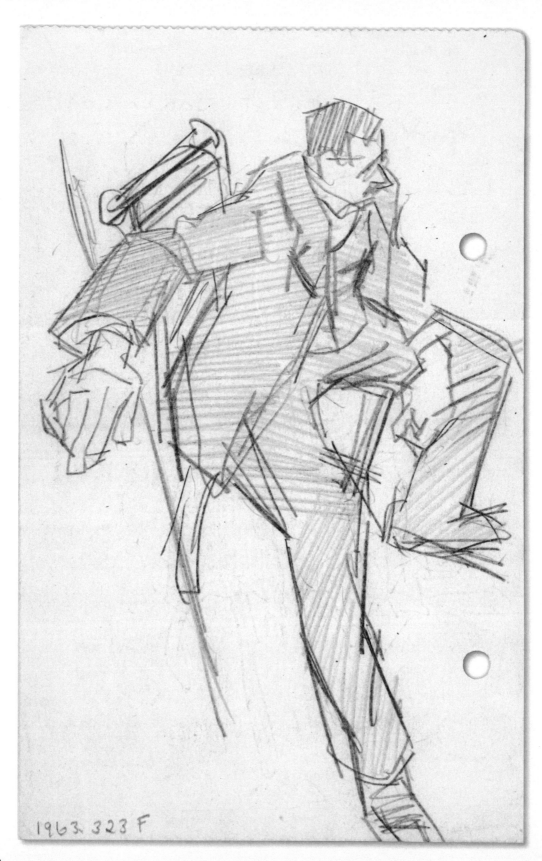

1963. 323 F

What's your angle?

This is a simple drawing of a man sitting on a chair but Feininger has made it visually dramatic by drawing him from directly above. Suddenly, the man's outstretched arm seems to reach out towards us, while the man's head appears unusually small in comparison.

This drawing pulls you in straightaway because of its unusual vantage point. We normally view the world from the same boring level – eye level – but here we join Feininger in his elevated viewpoint, looking down on his subject. Feininger has quite literally stepped up and completely changed his, and our, viewpoint. This gives us an unusual perspective; we see the figure from an angle that we aren't used to.

There is something else to consider. By changing your viewpoint in your drawing, you are also changing the viewer's perception of the subject. Looking down on someone or looking up at them has a definite effect on how we 'read' them.

Changing your viewpoint unlocks interesting compositional possibilities.

Untitled (Man on Bench)
Lyonel Feininger
1906

Ready for the close-up

This is a drawing zoomed right in. Maggi Hambling's wonderful ink drawing is a no-nonsense self-portrait, and there is no mistaking what the focus is here.

Hambling's brush-and-ink drawing of her eyes and messy fringe of hair cuts everything else out – the composition is cropped so that no other features are visible. There is a wonderful agitated energy in these ink lines and marks, but from this apparent chaos of marks, Hambling's eyes emerge dark and intense.

When you get in close to your subject, it won't be immediately obvious to people what they are looking at. As with Hambling's eyes here, it will take the viewer a few seconds to think and engage. We get used to seeing the big picture immediately – usually because we want things to be clear – but it's also good to create mystery, so don't always give the viewer everything. Cropping tight into your subject leaves people guessing what's going on beyond the edges.

Focusing on a detail changes the relationship between viewer and subject.

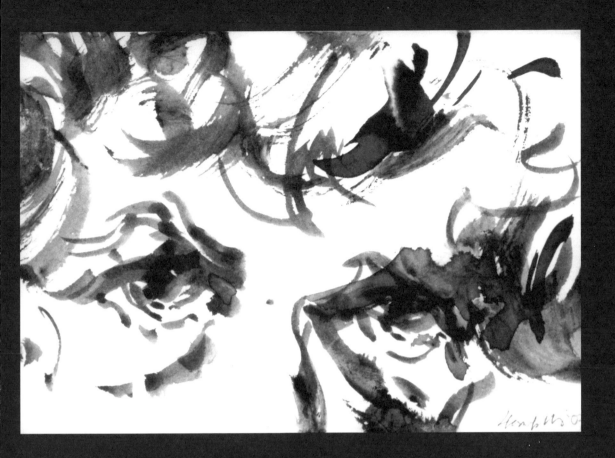

Self-Portrait (Eyes)
Maggi Hambling
2007

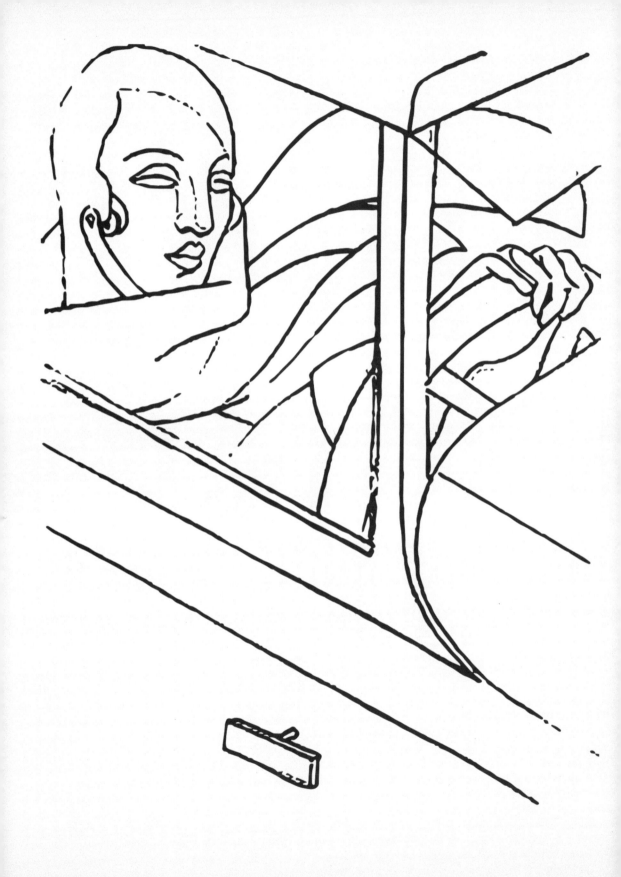

Rhythm and line

This is the study for one of the most iconic self-portraits of the twentieth century. Stylized and starkly linear, Tamara de Lempicka's *Autoportrait* is a bold statement of female independence. Sat at the wheel of her Bugatti she's a lady in control. The curves and lines of her face and hair merge with the arcing lines of the scarf to create a rhythm and flow across the whole picture frame. There is no separation between Lempicka and the things that she owns.

The exaggerated rhythmic lines of the scarf and the arrowed lines of the car create a dynamic composition. Speed, freedom and a love of life all summed up in one powerful, linear image.

The lines and shapes in your drawing create rhythm and direction, and as here, their swirls and curves take you on a journey with them. And like Lempicka, sometimes you have to exaggerate.

The viewer's eye should be able to connect every element.

Study for Self-Portrait
Tamara de Lempicka
1929

The power of space

What's going on in this drawing? The whole upper body is missing! Except for a single line – the arm and shoulder. And when you look carefully you can see that other things have been left out as well.

Empty space is a powerful compositional tool and Rambert uses it brilliantly. In this probing linear drawing the focus is drawn straight to the triangle of extremities at the bottom of the page. Nothing distracts from the intricate map of lines that describe the feet and the central hand as it rests on the knee.

This isn't a passive leaving out but an active, conscious decision to create empty space. You don't have to fill every inch of your composition. The space here highlights the beautiful sinewy lines as well as the clear triangular shape of Rambert's composition. This feels so balanced and looks so right that you don't realize at first how much of the figure has been left out.

Don't always feel the need to fill the page.

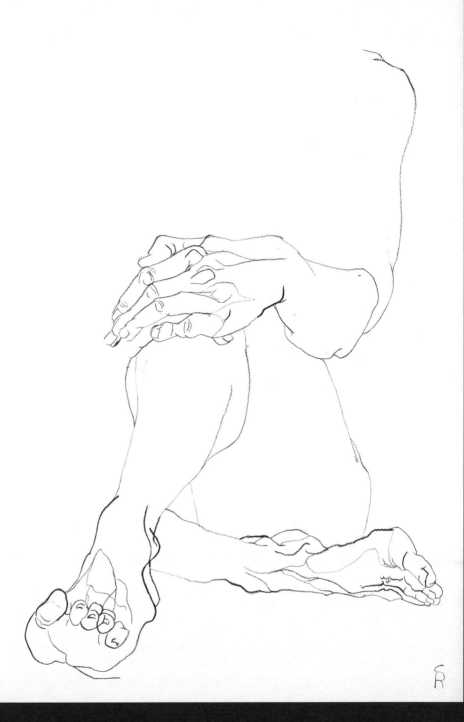

Mélancholie 10
Sophie Rambert
2010

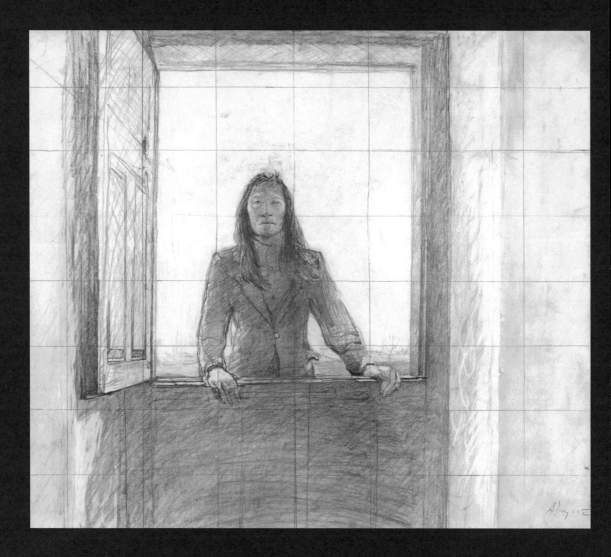

Nogeeshik Study
Andrew Wyeth
1972

Frame within a frame

Nogeeshik dominates this drawing. Framed by the open window, he stands proud and impressive, the empty space around him emphasizing his presence.

The frame of the open window underpins the composition in this preparatory drawing by Andrew Wyeth. This large rectangle gives him the perfect space in which to position Nogeeshik; the light of the bright sky behind him, left white and empty on the page, creates a dramatic contrast that accentuates his physical presence.

The frame is the key compositional element in this drawing, but it's subtler than that. Everything feels right. Nogeeshik isn't centred in the window, but the space around him just 'fits'. Everything feels poised and balanced, including Nogeeshik himself.

Framing your subject is a compositional device that you want to think about, and it doesn't have to be as obvious as a window. Look around you – where could you position your subject? It could be as simple as a patch of light, or against the darker tones of surrounding foliage.

Use a frame to focus the attention on your subject.

Hands up

Schiele created raw, angular drawings that remain totally distinctive to this day. Every person he used as a subject, and every part of that person, he drew in the same raw, unforgiving way.

In this drawing the hands are an integral part of the twisting pose. Schiele practically embeds the hands into the face, framing it and warping at the same time, and transforming the body into something strange and sculptural.

Don't leave hands till last – treat them in the same way as everything else. All of the techniques and tips that we've looked at so far also apply when drawing hands. As with the rest of the body, block them in loosely to start with, to establish their shape and position.

Use hands and limbs to make your composition more interesting.

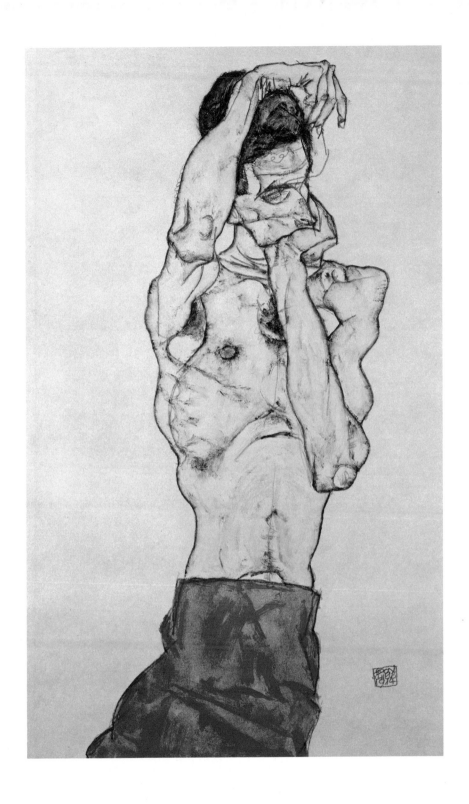

Man in a Red Loincloth
Egon Schiele
1914

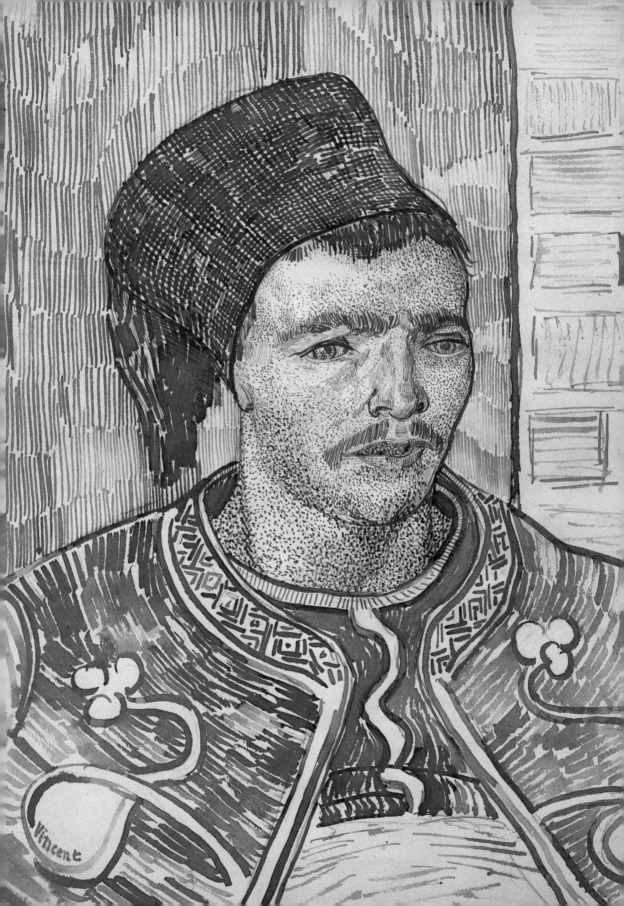

Vincent

Tone

————

Tone is simply the light and dark bits in a drawing. A tonal drawing has moved on from being linear, or just an outline, to developing areas of dark shadows and white highlights. Getting tone into your drawing – known as 'shading' – can be achieved in a variety of ways. This chapter will introduce a number of different shading techniques, but it will also introduce some new media, such as ink and charcoal. Different approaches to drawing people suit different media, and every medium is worth exploring.

Van Gogh's ink drawing of a Zouave, an Albanian soldier, is a masterclass in creating tone with different marks. He captures the vibrancy of the soldier's uniform by using long striations to curve around the patterned cape. The soft light on the soldier's thoughtful face is expressed with dots, or 'stippling' – packed close together in the dark areas, and further apart in the lighter areas. The background is made up of regimented vertical dashes. A variety of marks makes a striking whole.

The power of light and dark gives your drawing depth.

Take something that looks flat – a simple circle on a page. With shading, that circle becomes an orb, or a globe; it becomes something that you feel you could pick off the page. That is what tone can do. We are going to talk about lighting and mood in the next chapter, but for now we will focus on how to get tone on the page; the mechanics of shading. One thing you will notice in all the examples coming up is the sheer range of shades an artist can achieve, from really dark – almost black – all the way through to white.

The Zouave
Vincent van Gogh
1888

Look for lights and darks

Seurat captures the pose and posture of this seated woman perfectly. He concentrates his attention not on the curves or folds of the dress, or even on his subject's features, but rather on tone, covering the whole surface of the paper with consistent diagonal pencil marks, known as 'hatching'. The whole figure is created without any detail – it consists simply of shapes in different shades of grey.

Hatching is a quick and effective way of shading. You can adjust how dark or light the tone is by varying the pressure of your marks

and how closely you pack them together. Notice in Seurat's drawing the dense, heavy hatching at the top of the head and the chest, moving down to much lighter marks at the bottom of the dress.

When starting to build tone in your drawing, a trick is to de-focus your eyes so that all the detail goes, and you're just left with shapes of light and dark. The lightest area is the only area you leave blank, with the white paper showing through; then if you make the darkest area really dark, everything in between is available for use as your tonal range.

See the world as an abstract assortment of light and dark.

1.

Defocus your eyes so that you lose all detail and just see things as patches of light and dark. Start in the darkest area. Like Seurat I kept my marks diagonal.

2.

Now work across the whole of your drawing, comparing the areas of tone as you develop them. Make sure you make the darkest areas of shadow really dark. The white areas where the paper shows through should be the absolute highlights.

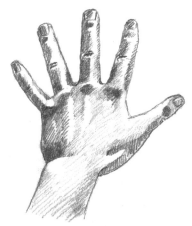

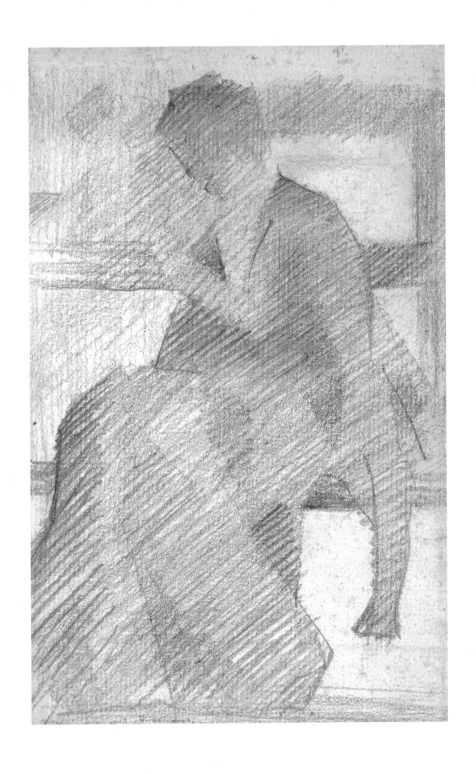

Woman on a Bench
Georges Seurat
c.1880

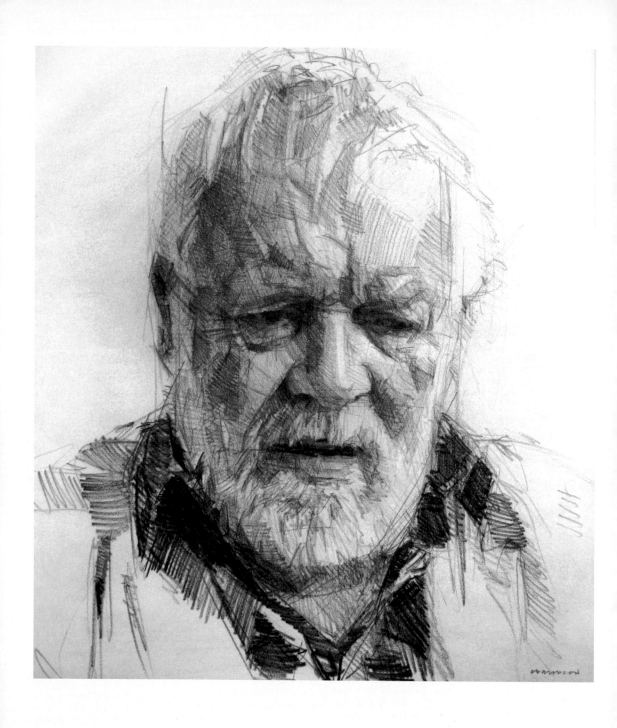

Michael Longley
Colin Davidson
2011

Hatch and cross-hatch

The poet Michael Longley's face is as expressive as one of his poems. The deep-set, mournful eyes, the mouth on the cusp of speech, are captured beautifully by Colin Davidson's energetic hatching and cross-hatching.

While hatching is the laying down of tone with parallel strokes, cross-hatching is the layering of parallel strokes on top of these, in a different direction, to build up a gradation of greys to black. Seurat, on the previous page, used very definitely diagonal hatching. Davidson,

however, uses both hatching and cross-hatching to describe the creases, lines and features of this old wordsmith's face.

A tonal range is necessary for creating a successful illusion of depth and form. It's not just the range of lights and darks that creates depth, though – the direction of marks can also really help describe the form of your subject, with vertical, horizontal and diagonal marks all working together to build up the final three-dimensional shape.

Hatching and cross-hatching give a tremendous tonal range, from the darkest shadows to the lightest greys.

1.
Draw your outline of the hand. Establish some broad areas of tone with simple diagonal hatching.

2.
Build up the darker areas with a diagonal hatch running in the opposite direction. Leave the lighter tones as the single hatched lines.

3.
Keep building up the layers of hatching to develop the dark tones. The lines don't all have to be diagonal; think about how the direction of the hatching mark you make helps describe the form of your subject.

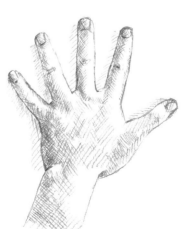

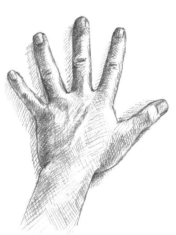

Quick and dirty

Zin Lim's drawing develops and shapes itself out of the rough scaffold of lines around it. The arm, head and leg are blurry, loose suggestions, guiding our attention to muscular back of the model, which Lim defines in much sharper focus.

Lim uses charcoal to achieve an incredible range of greys, which he uses to full effect to capture the beautiful modulation of the model's back. He starts off with quick, broad strokes, describing the general form, building up the dark shadows with very little detail. Then he works back into the charcoal with a finger, stump and putty rubber to pull the lighter areas out, while at the same time using a sharper piece of charcoal to work detail back in.

Charcoal is great for tonal drawings because you can cover large areas quickly using the side of the stick, and if shaped to a point, you can also create very precise areas of detail. It smudges easily, so keep your hands off the page when working on it, or cover any area of your drawing you're not working on with a clean sheet of paper. And when you have finished, make sure you apply a fixative over the top to preserve it.

Charcoal is a great way to establish tone quickly.

1.
Establish the rough structure of the hand and, with the side of the charcoal, block in the tone. You will work back into this, so don't worry if it looks too dark.

2.
Work back into the charcoal (with an eraser, cotton bud or other tool). Keep building up the shadows as well, with the charcoal.

3.
Bring in the detail. (Zin Lim uses a small, soft paintbrush to develop details, brushing away to create delicate areas of light.) Make sure the darks are really dark and the highlights really light. Rub out any smudges.

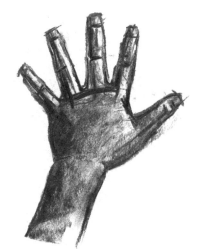

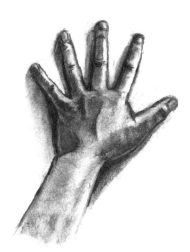

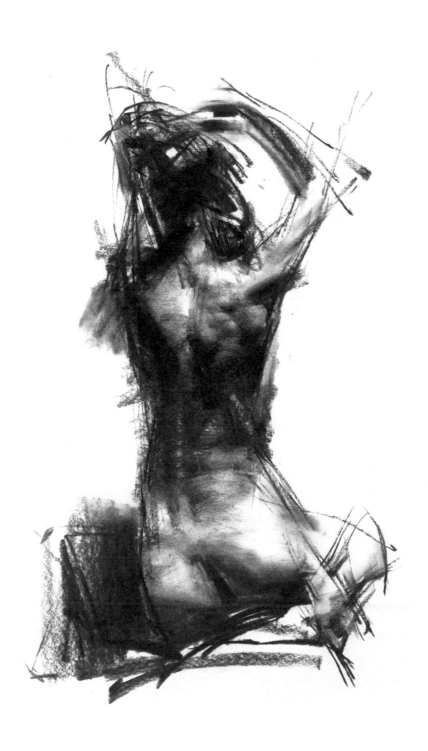

Allegro No. 87.3
Zin Lim
2016

Jason
Connor Maguire
2015

Not all paper is white

Connor Maguire works with charcoal and white chalk on textured brown paper to bring the expressive mobility of Jason's features to life. This drawing is different from others we've looked at so far. For the first time we're seeing work on paper that isn't white.

As with normal graphite, but in reverse, Maguire builds up the layers of white chalk with hatching and cross-hatching. The more layers, the lighter the surface. The charcoal gives definition to the features and hair, and also develops the shadows.

Working on tonal paper gives you a ready-made mid-tone, allowing you to concentrate only on highlights and shadows. Everything else is the same as with working on white paper; in the initial stages you will still need to determine the proportions and shapes of the features, before developing and working on the shading.

Let paper set the tone.

1.

With a white pencil, draw in your outline.

2.

Hatching and cross-hatching with the white pencil develop the areas of light. Press much harder with the pencil to create a more intense area of light.

3.

Using charcoal, bring in the shadows. The charcoal and the white pencil will blend slightly; the brown mid-tone of the paper helps bring these together.

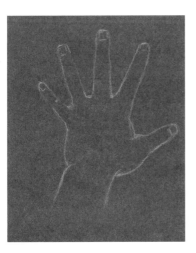

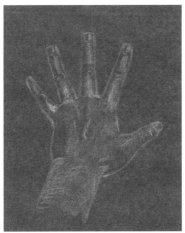

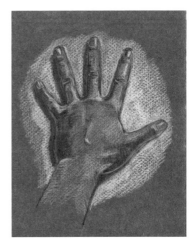

Go with the flow

Quick and spontaneous, these ink drawings by Tina Berning capture the slender elegance of the models with simple brushstrokes, and their sultry expressions with dark, inky pools of shadow. These are part of a much bigger series by Berning called *100 Girls on Cheap Paper*, published as a book in 2006 – a wonderfully diverse collection of the playful and powerful.

Berning's painterly drawings are little investigations that have an immediacy and freshness to them. Ink is great for spontaneity and can get you great results quickly, but once it's dry on the page it's there for good, so be brave.

There are numerous ways to apply ink to paper; here Berning uses a brush. This is a bit of a grey area between drawing and painting, but you can still draw with a brush. Make sure your ink is water-soluble. Undiluted ink will give you the darkest darks, and if you dilute the ink with water or dab it away with a tissue you will get lighter areas. Don't worry too much about precision or detail at this stage, just explore and experiment.

Ink is immediate and spontaneous and can create great results very quickly.

1.

Draw the outline with diluted ink and a round-headed brush with a good point. (If you want you can lightly draw an outline in pencil first.)

2.

Still using diluted ink, establish the shadows.

3.

For the darker areas don't dilute your ink as much. Be quite loose and quick with these drawings. It might take you a few trys to get the hang of it.

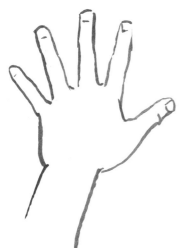

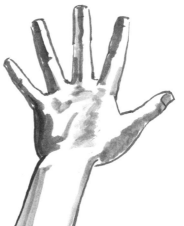

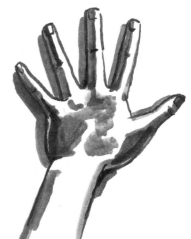

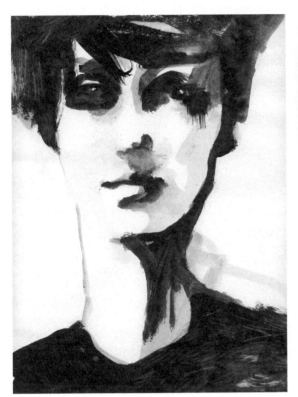
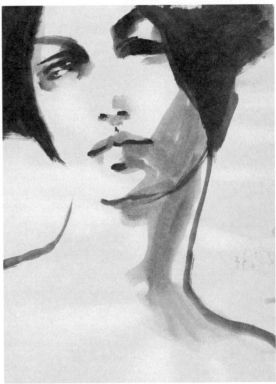

*Sketches from 100 Girls on
Cheap Paper*
Tina Berning
2006

Medium, materials and equipment

What we use to make a drawing has a big impact on the style and look of that drawing. A pencil is versatile and straight-forward, but it's also useful and fun to try different media. This can develop our drawings and move them into new and exciting areas. What I will stress at this point, though, is that if you don't enjoy any of these immediately, don't give up – give it another go!

Paper

Paper comes either loose leaf, in a sketchbook or on a roll, and there are many varieties. Most regular paper for drawing is cartridge paper, but you will get a feel for what you prefer. You don't need anything too fancy if you are just out sketching or experimenting, either. But there are a few things you should think about when making your choice.

SIZE

Pocket-sized sketchbooks are always good to have on you, especially for sneaky drawings of people on the bus. Bigger sheets of paper – from a large roll, for example – are great for gestural drawings and chunky charcoal pieces.

THICKNESS/WEIGHT

This is measured in grams per square metre (gsm for short). The range spans roughly from 80 gsm (printer paper) to 400 gsm (almost cardboard). A good-quality everyday drawing for most media would be about 120 gsm. If you are using ink washes you will need a thicker paper.

TEXTURE

You can get rough paper and smooth paper. The roughness of paper is called 'tooth'. The more tooth your paper has, the 'stickier' it will be for your pencil or charcoal, but highly textured papers can be very abrasive for these dry media. Thicker paper is often textured, for use with watercolours or ink washes.

COLOUR

Paper doesn't have to be white. There are many other colours and tones you can try. Browns and greys are common, and probably the best to work on if you want a neutral mid-tone paper to start on.

Pencil

The go-to tool for all artists. Pencils can be hard or soft or somewhere in between. Soft pencils are called Bs (for black) and give a dark line because more graphite gets left on the surface of the page; hard pencils give a lighter line but stay sharper for longer, so are good for more precision drawing. HB is somewhere in between. Different brands of pencil will also vary slightly.

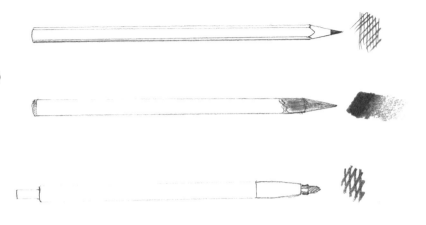

Charcoal and charcoal pencils

Charcoal as used for drawing is traditionally made from burnt willow. Compressed charcoal is powdered charcoal that, as the name suggests, has been compressed and consolidated with a binder; this gives similar effects to willow, although it can be harder to erase.

Charcoal is a crumbly, messy medium. If you are used to using pencil it might take a while to get used to charcoal. It also smudges very easily, so you have to be much more careful with where you put your hands.

A white pencil can be used on coloured tonal paper with charcoal or charcoal pencil to create lighter tone and highlights.

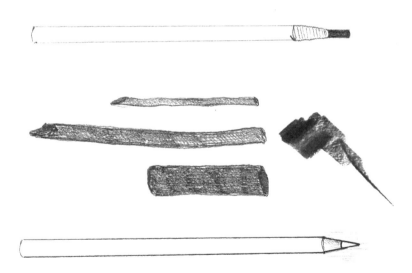

Ink

Ink is a liquid, and can be water-soluble or water-resistant. It can be used in a variety of ways and can give a range of effects, from light washes (when mixed with water) to strong, bold outlines. Once down on the paper, it's there for good. Drawing inks are usually black, blue or brown, but the colours will change when they are diluted.

There are a number of ways to get ink down on paper, and each method will give a different feel to your drawing.

FINE LINERS / BIROS / TWIN PENS

Easy and no mess. Fine liners come in a variety of sizes; they are usually water-resistant. Biros give a very regular line and are also water-resistant. A twin pen has a water-soluble brush nib at one end and a permanent thin nib at the other. These are great for both washes and detail.

BRUSHES

The brush is a great tool for ink. Using one is a bit like painting but you're just moving the ink over the page to where you want it. A brush can produce an incredibly thin line at the tip, or a much broader one if more pressure is applied.

REED PENS / DIPPER PENS

These pens are very simple. They are sharp-tipped, and usually bamboo, metal or wood. These are dipped in the ink and then used just like a normal pen but they have a slightly less consistent line.

FOUNTAIN PENS

These are metal-tipped, with an ink cartridge, so you don't need to dip them in ink.

They give a more regular line than dipper pens, but this can still be varied by using different parts of the nib.

Additional materials

BLENDING TOOLS – STUMP / COTTON BUD / CLOTH

Blending tools help smooth any gradations from dark to light, or can be used just to soften a line. A stump is simply a small rolled piece of paper. Stumps and cotton buds can be used for both pencil and charcoal. A clean cotton cloth is useful wrapped around your finger to help with blending.

TIP:

A clean piece of paper placed over the top of a charcoal drawing will prevent it being smudged where you don't want it to be smudged.

SHARPENER / BLADE FIXATIVE

Fixative or hairspray, either is fine. When you are using a dry media like pencil or charcoal, spray it when you have finished to stop it smudging.

RUBBERS – PUTTY RUBBER / PLASTIC RUBBER

A rubber's great for erasing mistakes and cleaning up all the smudgy bits when you've finished your drawing. It can also be good for rubbing back into your drawing to create highlights. Putty rubbers are soft and malleable, so can be shaped easily. If you use a plastic rubber you can cut it with a blade to get a sharp point or edge.

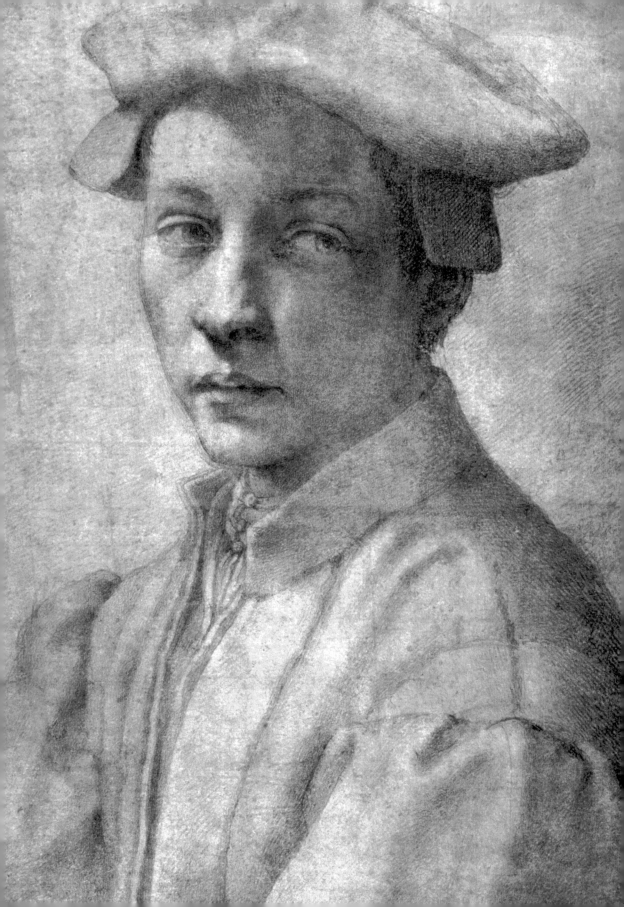

Lighting

This portrait by Michelangelo of his friend Andrea Quaratesi demonstrates a classic use of light and positioning to capture a model's features. Michelangelo has positioned his sitter with his shoulders turned at three quarters, and his head turning back to look at the artist. A soft, natural light comes from the top left, striking the right of Andrea's face and casting enough shadow to create a sense of depth.

Lighting reflects the mood of the subject and yourself.

Think of light in two distinct categories: natural and artificial. You can work with natural daylight, whether you are working outside or inside. You don't have any control over the weather, but you can choose the time of day. You also have control over your position relative to your subject's, and the direction of the light striking both of you.

Light has two different qualities: hard and soft. These qualities can apply to both artificial and natural light. Hard light is bright, giving strong, distinct shadows. Soft light is more diffuse and has the effect of wrapping around a subject. Light at midday is much harder than light during the early morning or evening. A bright lamp will give a hard light, but this can also be softened.

The examples in this chapter deal with drawings both in and out of a studio environment. In each example the artist has worked with, or created, a lighting effect that influences the way the subject is viewed. The light gives each drawing its own feeling, ranging from dark and moody to bright and stark.

Portrait of Andrea Quaratesi
Michelangelo Buonarroti
1532

Set-up

If you are drawing people in your own environment, then you need to be able to set this up in a way that is most effective for you and comfortable for your sitter. Your 'studio' could even be your living room – it just needs to be somewhere you can control the environment, and especially the light.

Model

WHEN WORKING FROM A MODEL REMEMBER:

1 Your model must be comfortable.

2 Give your model regular breaks.

3 Mark the position of your model before they stop for a break.

A Easel – positioned to get the desired view of the model.

B Chair – for you to sit on if you are working with a sketchbook instead of an easel. As with the easel, position it to get the desired view of the model.

C Donkey easel – combines a chair and an easel! Again, poistion it to get the desired view of your model.

D Backdrop

E Spotlight

F Softbox light

G Blackout blind

H Stool for model (fabric/props optional)

I Heater or fan

J Plinth/platform for the model

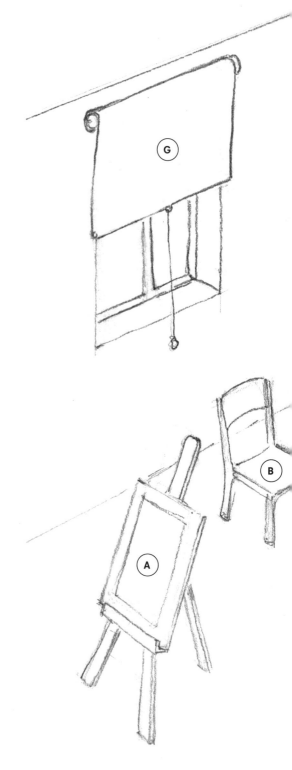

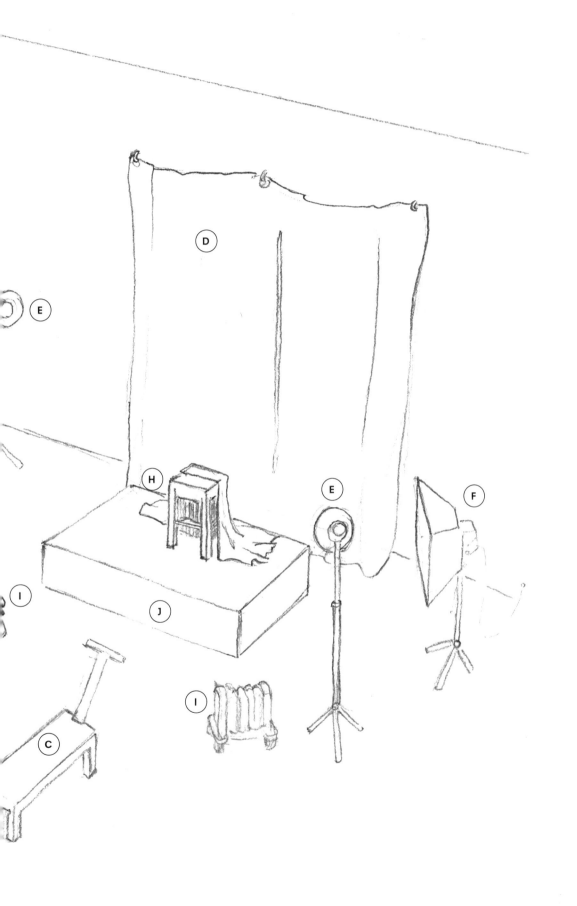

Out and about

**WHEN WORKING OUT
AND ABOUT REMEMBER:**

1 Always have a sketchbook and pencil
 or pen with you. Then whenever
 you're out and have a spare few
 minutes you can spend them
 drawing.

2 Keep it candid. Good places to draw
 people are trains, buses or even your
 local café.

3 Pick a spot that has lots of people to
 draw and keep your drawings quick.

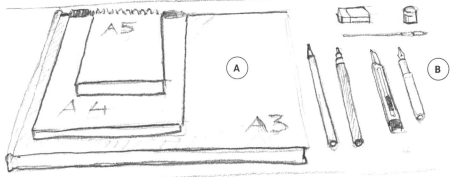

A Sketchbook – pick a size
 you are comfortable with.
 A5 (or even A6) is good to
 have with you all the time in
 your pocket. Don't go bigger
 than A3, as it will be too
 cumbersome and obvious.

B Pencils and pens – again,
 choose whatever you are
 most comfortable using. If
 you what to work with ink
 you'll need a small brush and
 pot for water (you can always
 just use a lid from a water
 bottle).

C Stool (totally optional) – if
 you are sketching in a café or
 on a bus there is obviously
 no need to bring your own
 seat. But if you want to set
 up in a town square or other
 public outdoor space it can
 be good to have.

D Bag – this is for carrying
 sketchbooks and equipment
 when you are working on a
 slightly larger scale.

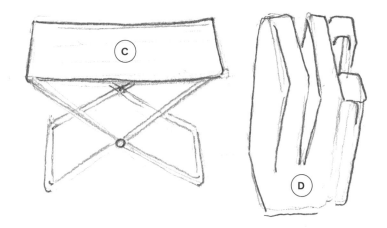

Self-portrait

1 Be sure you have a comfortable chair. You will be sitting for some time.

2 Lighting yourself is important. Remember that lighting from an angle slightly to the side helps create interesting shadows. Spend some time getting this right.

3 Be sure you can see yourself clearly. A tabletop easel is good because you can use it to support a mirror, which you can then raise to be level with your face. Be aware that if you have your mirror propped up on something it will probably be at an angle that will affect the view of your face, making your chin and neck more prominent.

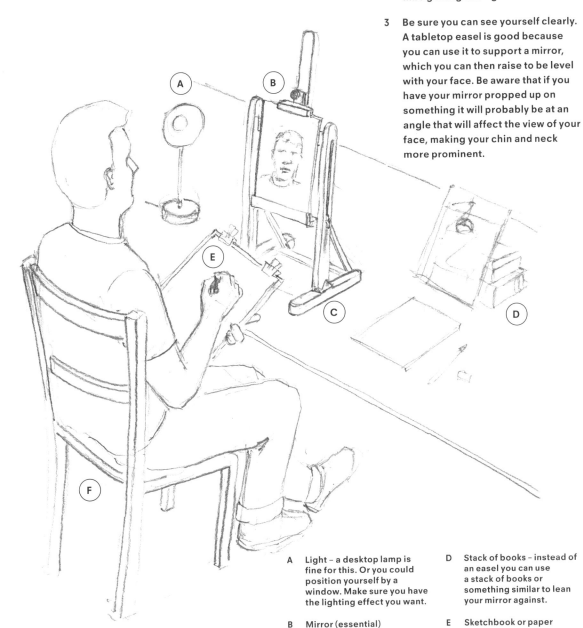

A Light – a desktop lamp is fine for this. Or you could position yourself by a window. Make sure you have the lighting effect you want.

B Mirror (essential)

C Tabletop easel (optional) – this is very useful, though, for adjusting the height and position of your mirror.

D Stack of books – instead of an easel you can use a stack of books or something similar to lean your mirror against.

E Sketchbook or paper on a board.

F Chair

Create contrast

This drawing by Mark Demsteader packs a real punch. The lighting turns an otherwise simple pose into something dramatic and impactful.

Demsteader's figure drawings are expressive and utterly distinctive. His innovative technique uses a variety of media to build up the surface of his drawings, but it is the intensity of the dark shadow areas that makes them so arresting and alluring.

Demsteader lights Kate from directly above with a strong, hard light. Her eyes are completely obscured by deep puddles of shadow, which also swallow up the bottom of her face. Light strikes the top of her head, making bright highlights on her forehead, nose, cheek and top lip. The contrast of highlights against the rich, dark tones creates a powerful portrait.

Hard light creates powerful lights and darks.

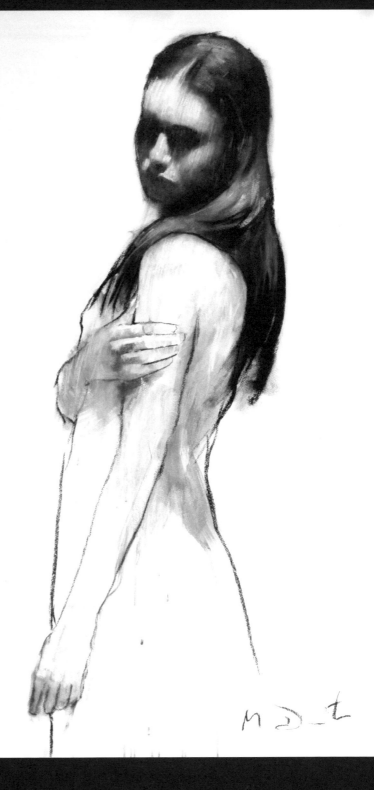

Kate Standing
Mark Demsteader
2008

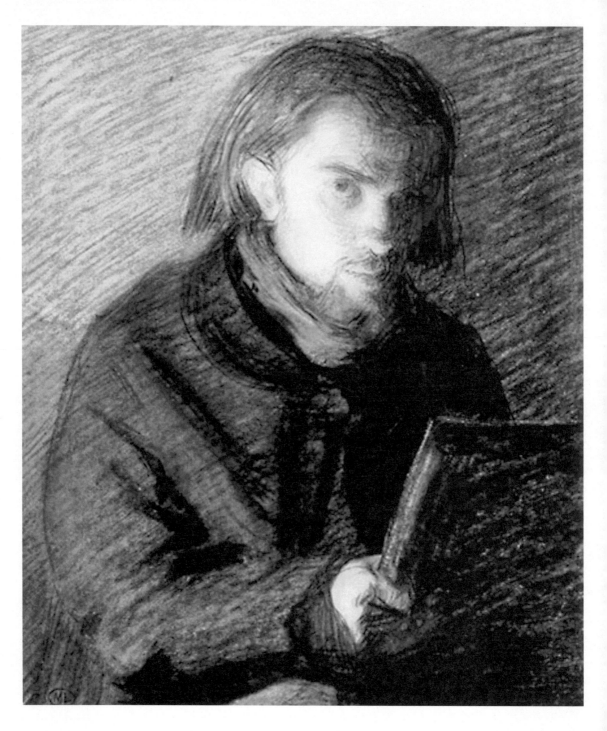

Self-Portrait
Henri Fantin-Latour
1860

Explore your dark side

Most of this drawing is in shadow. Only half of Fantin-Latour's face is illuminated, and yet the artist's presence in the drawing is amplified by the darkness.

The lighting here comes from a single source off to the left. It creates heavy swathes of shadow that give Fantin Latour an air of brooding introspection. He stares at the mirror – and at us, the viewer – clutching his sketchpad, hair swept back behind his ear. The lighting in this drawing reinforces the image that he wants to project – that of a deep, intense artist.

The shadows that come from side lighting with a single light source give drawings a distinct character. Shadows will obscure some elements so that you don't show the viewer everything. Keep things deliberately moody and mysterious by letting your subject emerge from the darkness.

Shadow can change the mood of your drawing.

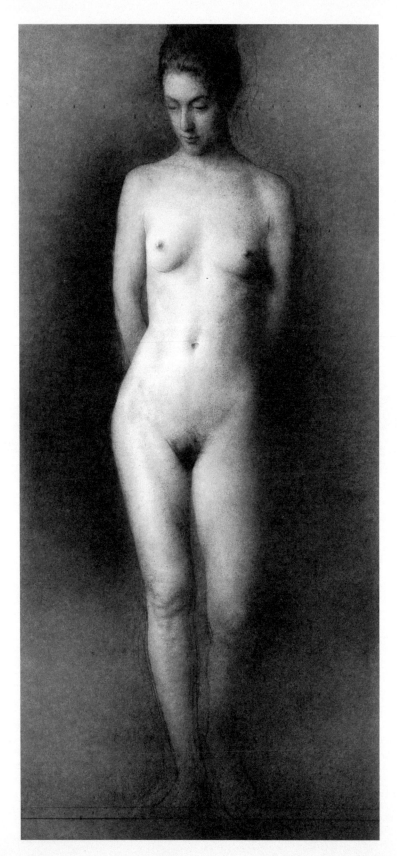

Figure
Paul Emsley
2004

Be gentle

The figure emerges from the dark background: she stands in the classic contrapposto pose, eyes cast down. Everything about this drawing is calm and quiet; if it were a person it would be whispering soothingly to us. Even the light is beautifully discreet.

Emsley lights the figure from the left of the frame. But this isn't the hard light of Fantin-Latour – there is no hard contrast – this light caresses the form of the model gently. It still creates depth and form but it does so with a whole symphony of greys, from the lightest on the left, to the darkest on the right.

A soft directional light will accentuate the form of your subject. Make sure you take the time to really build up the full array of subtle greys across the whole surface of your subject.

Soft light wraps around the form.

Bright and beautiful

Michael Landy draws his portraits like a scientist drawing a specimen. His subjects are measured meticulously before being committed to paper, every aspect of their face documented in unflinching detail.

This no-frills portrait of his wife, Gillian Wearing, is one of a series of pencil portraits made under the same conditions, with a consistent result. Landy drew all these portraits in pencil, front on, with very little shading. The lack of shadow has the effect of laying the face out flat, like a map of features. Such portraits are not about mood or depth – they are about seeing everything with absolute clarity.

Landy drew these portraits in a white space with big fluorescent lights bouncing light all over the place. Fluorescent strips give a diffuse light that fills a space; it gets rid of the shadows, so is perfect for revealing every detail, enabling it to be recorded with forensic precision.

Frontal light eradicates shadows and flattens your subject.

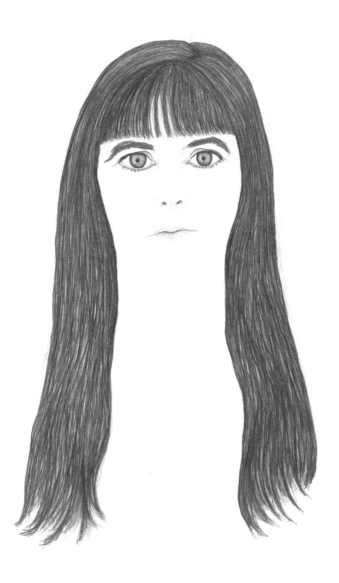

Gillian
Michael Landy
2008

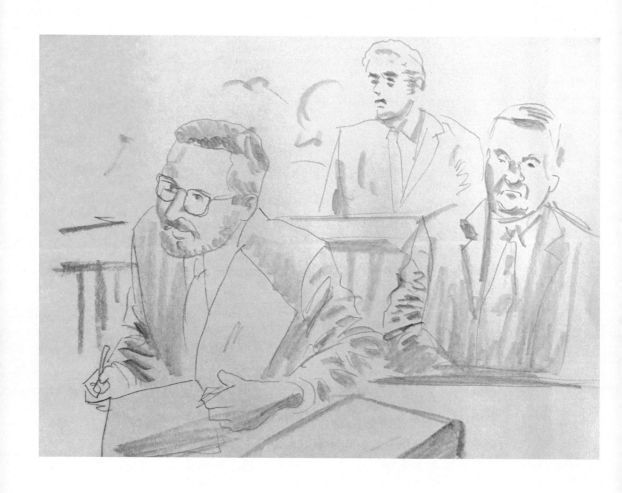

Courtroom Drawing
Wayne Shellabarger Fox
2008

Sum up in broad strokes

As a courtroom artist, Wayne Shellabarger Fox has to deal with lighting that is artificial and functional, washing across the whole scene. No one in a courtroom is posing or even thinking of the artist sketching away. I guess they all have other things on their mind.

The artist has only seconds to capture the body language and expressions of the people in front of him. He does this with a skilful blend of tone and line. Broad strokes from the side of the pencil create areas of tone quickly.

Then the tip of the pencil creates a sharp line for definition.

Not only does this technique capture the expressions of the protagonists in this drama brilliantly, but also the atmosphere of the whole courtroom, with its bright, unforgiving lights.

We can see this with the broad pencil marks that are used to suggest the rails behind the two main figures, and the quick squiggles and strokes that so effectively sum up the idea of other people in the courtroom.

Find the marks that suggest rather than define.

Lighting

Light is around us all the time – including right now, as you're reading this – but how often do you really pay any attention to it? Not that often, probably, but when you draw people you need to start paying attention – really studying what different lights do, and the effects they have on what you look at and, ultimately, what you draw.

Hard light

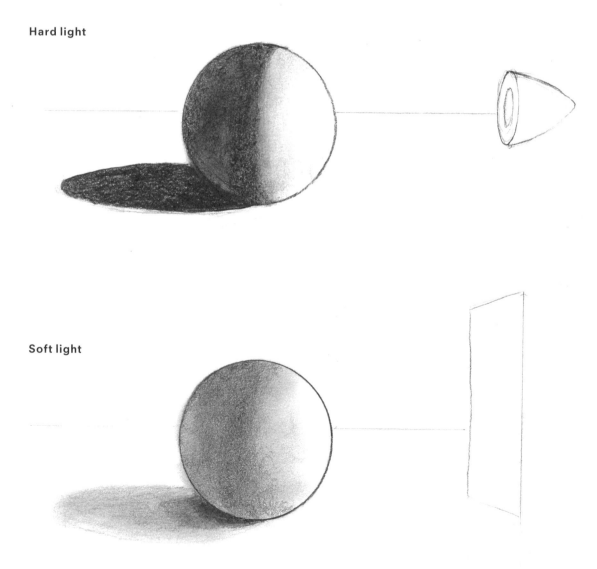

Soft light

Lit from below

Lit from above

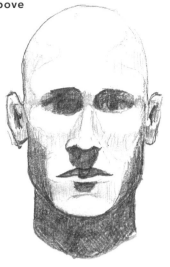

Lit from the side

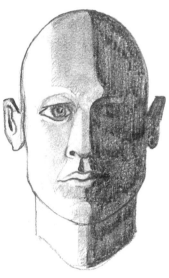

Lit from above and the side

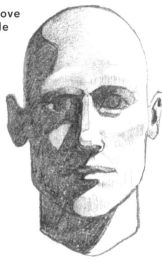

Lit from the front

Lit from below and the side

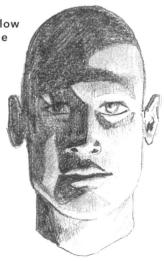

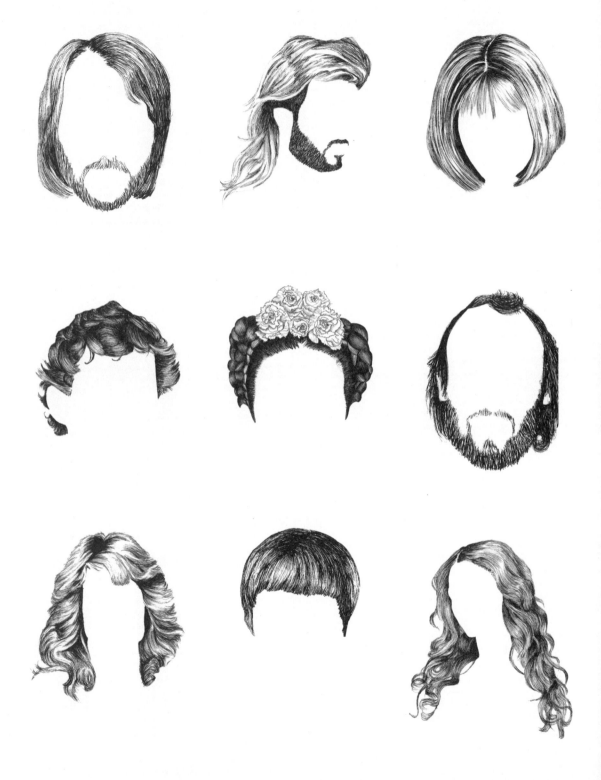

Individuality

———

How do we recognize each other? What makes us all unique? When drawing a person we have to identify and then capture the particular quality that makes them 'them'.

We have done the 'getting things in the right place' bit, which is vital, but now we need to develop our craft. What makes people individual is key when drawing people. The first port of call is obviously the features, which blend together to make each one of us distinctive and recognizable.

Look at these hairstyles. It's funny to see them floating on their own with no head or face to support them. But look at how recognizable they are. By drawing just this feature, Christina Christoforou begins the process of finding the individual.

Start with facial features but don't stop there.

Take a look around you – who can you see? What makes them individual? Look closely and think differently. What about the angle of their head, the way they stand, what they're wearing, or the objects they have around them? These are all there in front of us, and as artists we have to train ourselves to see them properly. So, take a few minutes and have a good look.

People Are Unique
Christina Christoforou
2010

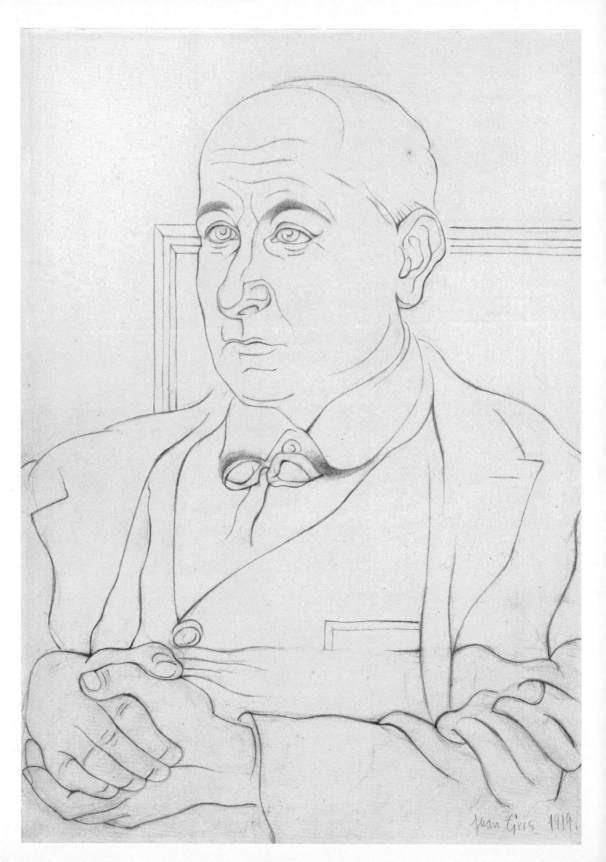

Find the shape

Our features are all distinctive – that's how we recognize each other. Big nose, flappy ears, a little turn-down of the mouth. In this tight line drawing of Max Jacobs, Juan Gris condenses the complexities of his friend's face with simple, clear shapes.

There's hardly any shading in this drawing, but the lack of tone highlights the carefully crafted shape of the features. Gris spends time delicately delineating every nuanced curve – the furrowed brow, the slightly bulbous nose all are distinctive. And where there might have been shadow, Gris concentrates on shape.

When drawing a face, it's easy to get lazy and just assume you know what the shape of a nose or an eye is, then draw that. But that is not necessarily the shape that is actually in front of you.

Forget your preconceptions and draw what is really in front of you.

Portrait of
Max Jacobs
Juan Gris
1919

Make the features real

Despite the still composure of this composition, Holbein skilfully animates the face and features of his fashionable sitter, with her level gaze and hint of a smile. The introduction of tone with touches of chalk makes her so lifelike it's almost as if she were about to speak.

Like in Gris's drawing, the features of Holbein's sitter are beautifully observed and drawn, but whereas Gris uses only line to describe the features, Holbein combines a sharp outline with light and shadow to give the woman's face form and depth. Delicate modelling of light and dark catch the contours of her high cheek bones and delicate nose.

Without shading, a face will always look flat. You don't need dramatic lighting effects here; subtle shading is enough to bring the features of your sitter to life.

Tone brings features to life.

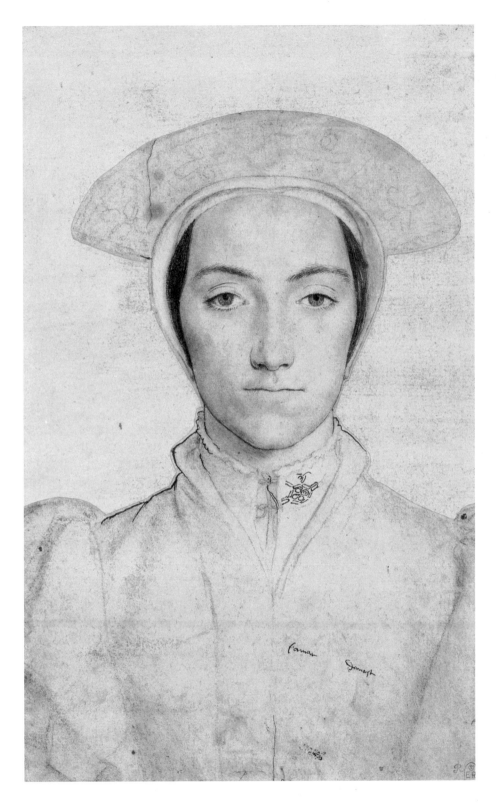

Portrait of an Unidentified Woman
Hans Holbein the Younger
1540

Linear (Manjit, Canary Wharf)
Dryden Goodwin
2010

It's good to talk

This drawing is part of *Linear*, a series of 60 portraits by Dryden Goodwin of people who worked on the London Underground's Jubilee Line. In these portraits Goodwin concentrated purely on each subject's face – no clothes, no props, no background, just their whole story told through their features.

Goodwin also chatted to his subjects as he drew them, getting to know them and setting them at ease. This enabled him to see the sitter he was drawing as a real person, not a stiffly posed model.

However, this also meant that Goodwin's subjects would move as he was drawing. So his technique is all about adaptation – there is no one crisp, 'correct' line. He works on top and adapts as the subject moves.

Getting to know a subject as you draw them will help bring out their personality in your drawing. As you proceed, you may have to draw over the top of some of your lines, but as they build up you will create a rich matrix of lines that capture your subject.

Allowing your subject to talk lets them reveal themselves to you as an artist.

Unposed and genuine

The whole feeling of this drawing is one of a natural, candid snapshot of a writer at work. A picture of concentration.

Rowling's face is mostly in shadow, and her hair is natural – a few loose strands catch the light as they fall across her face. This drawing wasn't set up; it was done at Rowling's Edinburgh office – one of a series of drawings that Stewart Pearson Wright made, capturing the author in her day-to-day routine.

We can't see the location but that doesn't matter – Rowling fills the frame; she's the star of this drawing, and her pad and pen give all the clues, if any were needed, as to who she might be and what she does.

Pearson Wright took the scene, light and all, exactly as he found it. His subject was obviously aware that she was being drawn, so he was able to get in quite close. Luckily, though, it looks like it would take a lot to distract JK Rowling from her work.

When working from a subject who is occupied, be mindful of what they are doing. Remember that they are not a model, so spend time finding your best position and angle. You can ask them to do small things, however, if it's not too intrusive – like pulling their hair back from their face.

Drawing people in their natural environment can reveal more about them.

TIPS:

1. In these situations your subject is aware of you, but always be mindful of their working situation.

2. Spend time finding the best position to draw in. It's up to you to find the best angle.

3. Remember that regular sitters are not models, but you can always ask them to do small things, like pulling their hair back from their face.

JK Rowling
Stewart Pearson Wright
2005

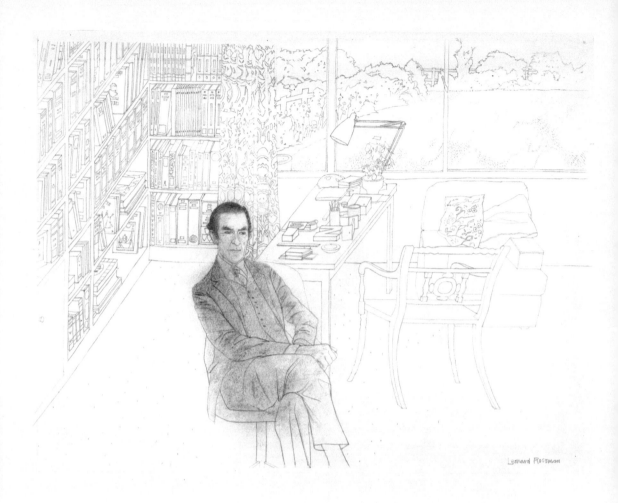

Nicolas Clerihew Bentley
Leonard Rosoman
1980

Be an environmentalist

Look around you? Do the things around you help define you?

In this portrait, Rosoman places his subject, an author and illustrator, firmly in his natural habitat. Surrounded by his books and the tools of his trade, Clerihew Bentley sits comfortable and assured in his environment.

The spaces we occupy, at work, at home or even in our car, are full of the trace elements of 'us'. As artists it's important to be able to see and to use everything we can to describe the people we draw, and the background can be just as important as the subject itself. The details in Rosoman's drawing are one way to go, but not the only way. Whether you strip all context away or place your subject firmly in a place, make that a conscious decision.

Putting your subject in context gives clues as to their character.

Think in reverse

Who is this? We can't see a face, but we can look for the clues.

A portrait like this is brave, because most people expect to see the face of the person you're drawing. You have to work a little harder in some ways to make a drawing like this, but it's worth it when you can create something as unique as the individual themself.

You don't need to show someone's features to show their individuality. I wear a silver bracelet on my right wrist, and never take it off; it has become a feature of me that would be immediately recognizable to anyone who knew me. Find something about your subject that gives them away without having to draw their face.

We don't need to see a face to recognize who someone is.

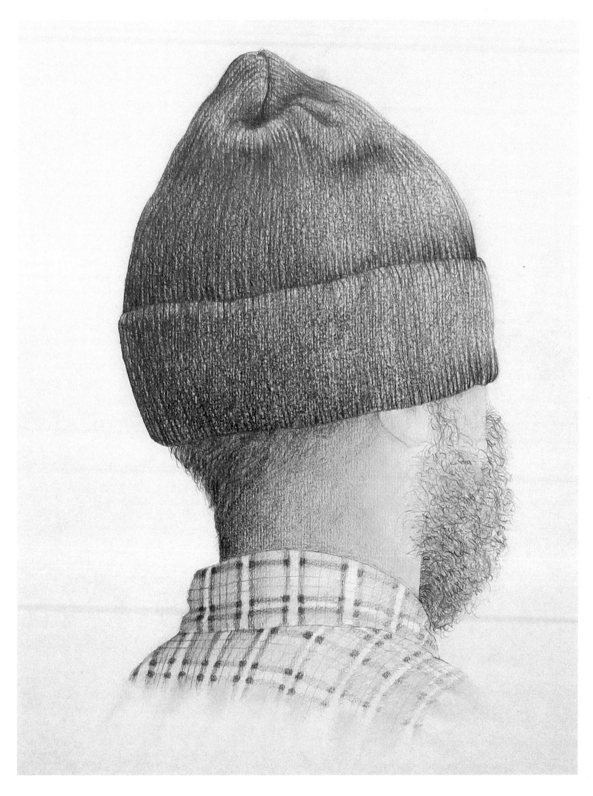

Reverse Portrait
Nettie Wakefield
2011

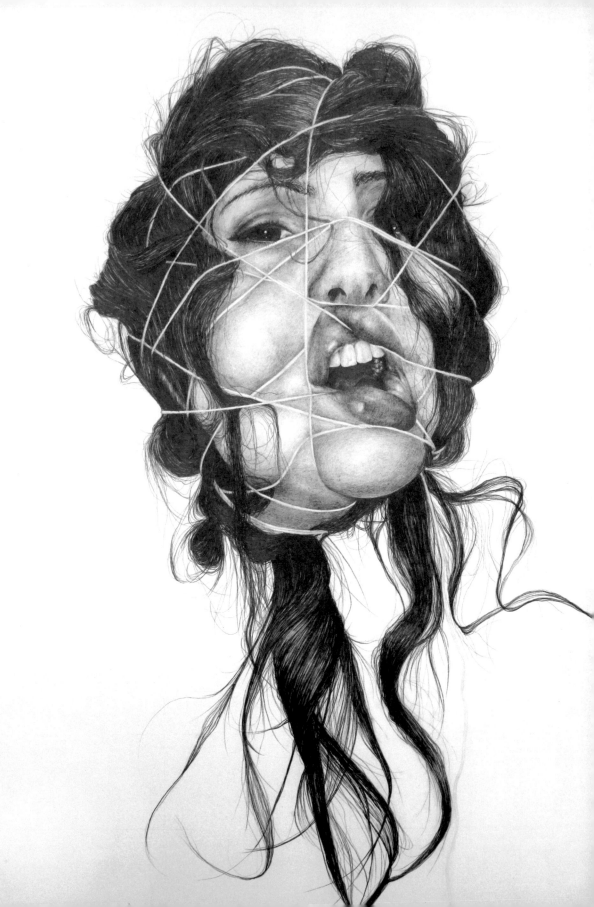

Approach

The drawings in this chapter all represent the artists' desire to find different ways of expressing themselves. The ideas that underpin the drawing now begin to take centre stage; technique is still important, but with these drawings, it is led directly by the concept. The thing to remember is that it's your drawing, so take control.

It's OK to do things differently.

Gillian Lambert likes to play around with her self-portraits. She twists, grapples with and obscures her face to create portraits that challenge us to re-evaluate our ideas of self-image, identity and beauty. In *String* Lambert presents herself in a grotesque tangle, bound and vulnerable. The tension between the beautiful drawing and the discomfort of the subject creates a provocative ambiguity. Nothing has to be obvious or 'normal' when drawing people. Make the viewer uncomfortable, or even confused, because sometimes it's just about making people think.

This chapter is about feeding the imagination. We're going to look at artists who have done things differently – who haven't trodden the traditional path when it comes to drawing people.

String
Gillian Lambert
2011

Mix it up

The face and features of this girl are beautifully lifelike, and her dress is almost abstract. It's hard to figure out what grabs the attention more – the intense gaze of the girl, or the strange defined texture of the rock dress.

This drawing is one of a series in which Anderson took her inspiration from the sea and nature, combining the beauty of the natural world with the beauty of the female expression.

This highly polished drawing looks like an image from a fashion magazine. The discreet stippling makes for subtle shading of the face and arms. The flat, abstract rendering of the rocks – symbolic of the strength of nature – is enhanced by the contrast with the soft tenderness of the girl's face and figure.

You don't have to draw everything exactly as you see it. Like Anderson, try mixing things up. Think about what you want to say about the person you're drawing, and add in an object that underlines that idea.

A strong idea can be enhanced by an unusual juxtaposition.

The Certain Unknown
Kirrily Anderson
2016

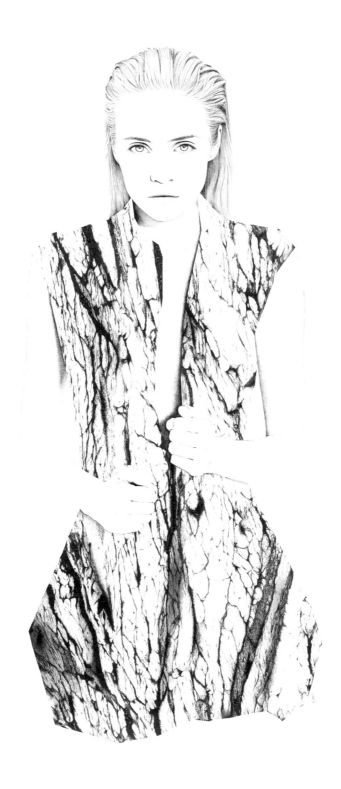

Two pens (or pencils) are better than one

Two different styles, one great statesman. A soft, sensitive graphite drawing on one side. On the other, a bold, black, linear style, with clear, crisp lines, and a cigar that takes the form of a great tube of black with a bright red disc burning at the end.

These two contrasting styles – the graphite of Nestor and the graphic of Shout – are jarring and complementary at the same time. Nestor's and Shout's styles are different, but they have worked together to create an exciting and unusual depiction of a man whose famous face has been drawn, painted and reproduced many times over the years.

Collaborate with a friend on a portrait of someone famous and see what happens. You'll have to set some ground rules – for a start, you will have to work out who's doing what – but once you've got that figured out, let the drawing evolve and keep an open mind as to what the end result might be.

Working with another artist gives your outcome an exciting uncertainty.

Churchill
Denise Nestor in collaboration with Shout (aka Alessandro Gottardo)
2012

Don't hang on to something that isn't right

Turing, Wilde, Nureyev. The mathematician, the aesthete and the dancer. Three very different people, all geniuses in their own ways, but all defined and oppressed by society in their time because they were homosexual.

Marlene Dumas undertook a series of 16 ink drawings to celebrate 16 inspirational men whose lives and creativity were shaped by their sexuality. To capture their complexity and their genius, Dumas did not make just one version, she would draw again and again until she was happy.

Dumas starts a drawing with a very specific look in mind, one that encapsulates the spirit of her subject. She never works from life, choosing instead to work from a range of photographic images to build up an idea of a person. Working in ink for these portraits meant she couldn't erase any mistakes, which is why she would make so many versions, constantly redrawing her subject until it felt like they were really present on the page.

No matter how long it took, if it didn't work, it didn't work. And that's OK.

ALAN TURING (1912 - 1954)

The father of the computer science

died of cyanide poisoning

His homosexuality resulted in a criminal prosecution in 1952. He was offered the choice of going to prison or chemical castration.

Oscar Wilde (1854 - 1900)

Was an Irish writer and poet and one of the most successful playwrights of late Victorian London. Imprisoned in 1875 for two years hard labour for gross indecency with other men.

"Art is individualism and individualism is a disturbing and disintegrating force, therein it's immense value. For what it seeks is to disturb monotony of type, slavery of custom, tyranny of habit and the reduction of man to the level of a machine."

Rudolf Nureyev (1958 - 1993)

World Famous Soviet-born dancer of ballet and modern dance. He provided a new role to the male ballet dancer who once served only as a support to the women. Defected to the West in 1961.

Great Men
Marlene Dumas
2014

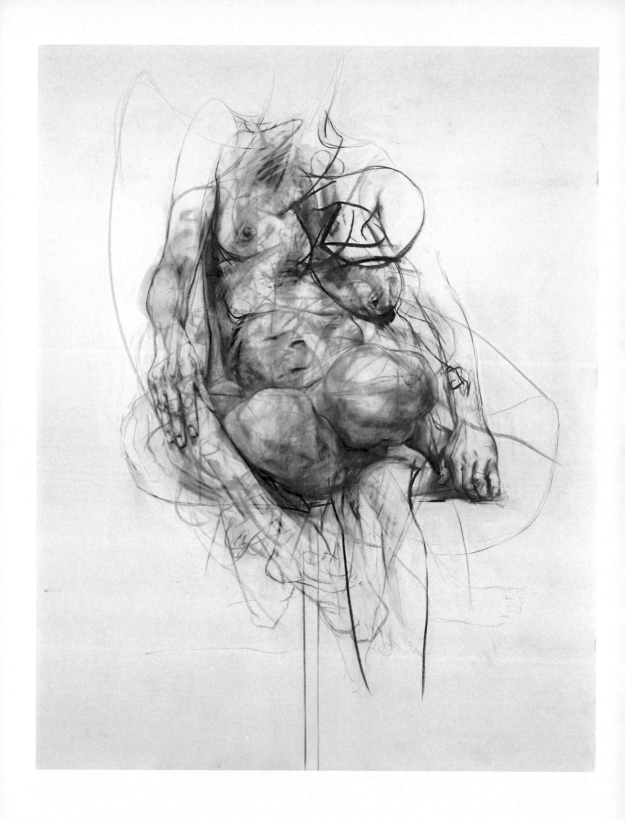

Muse on Stool (study)
Jenny Saville
2015

Big is beautiful

We are not a camera. We don't, as artists, have to produce an exact replica of a person. The exciting thing with drawing is that it can show the complexity of the human condition as well as the complexity of the human form. And that is exactly what artist Jenny Saville does.

This complex, layered drawing is big – over 6 feet. It's literally larger than life. On this scale, the shifting, morphing body fills our field of vision. The faceless anonymity of the figure means that our full focus is on the body. We crave to make sense of it. We want to find one coherent form but can't because Saville buries drawing under drawing under drawing.

Like a physical presence in its own right, Saville's exploration of the female form is even more open and exposed to the viewer's gaze because of its size. Don't be put off the idea of working big because of logistical concerns; clear a wall. You can buy paper on a roll, or even use wallpaper lining paper. Just give it a go.

Being bold with scale can amplify your idea.

Draw with feeling

Some drawings you look at and get straight away. Others take some time and a bit of context to understand. This drawing by Claude Heath definitely falls into the latter category.

A dense web of multicoloured lines swirls out from a clear white hole. There is an energy to these lines, but they aren't random squiggles by any means. These are four drawings of a cast of Buddha's head. But the reason that this is like no Buddha's head we have seen before is that they were drawn blindfolded.

In his drawings, Heath uses nothing more than his sense of touch, abandoning what he thinks he knows about a face in order literally to draw what he feels. As his left hand touches his subject, his right hand draws it, transposing his exploration of the three-dimensional into two dimensions. We are used to discovering and experiencing the world around us with our eyes – what we can see – but Heath does this with touch.

This way of drawing is not about representing what you see, but about representing what you feel, like mapping a sensation.

Drawing doesn't always have to be of what you see.

Buddha
Claude Heath
1996

Thumbs up

What better way to identify someone than with their fingerprint – more unique than any feature on our face. Yet this playful work by Saul Steinberg is like the amusing love child between identity and anonymity.

This was Steinberg's comment on corporate conformity, the drawing acting as a faux passport 'photo'. A crisp thumb print creates a clear oval that takes the place of the head. The shoulders and tie are also made up of fingerprints, with masking tape used to clearly define the edges of the jacket and tie.

Steinberg was a serious artist with a great sense of humour; his cartoons and artworks reveal someone who never took himself too seriously. In the end, although it's important that drawing is taken seriously, it should never stop being fun.

Serious ideas can be expressed in funny ways.

Passport Photo
Saul Steinberg
1953

Index

ACKNOWLEDGEMENTS

I'd like to thank my fantastic girlfriend Caroline for her help and support throughout; thank you to everyone at Laurence King Publishing, especially to Jo Lightfoot, Alex Coco and my editors Sarah Silver and Donald Dinwiddie whose kindness and patience is seemingly inexhaustible; thanks to James Lockett at Frui (www.frui.co.uk) who always has ideas; thank you also to Brenda Vie for her knowledge and advice and thanks finally to Henry Carroll (www.henrycarroll.co.uk) for all his help, guidance and insight throughout.

CREDITS